The Conversation Series

© 2008 Olafur Eliasson, Hans Ulrich Obrist, and
Verlag der Buchhandlung Walther König, Köln
Photo credits: © Studio Olafur Eliasson
p. 11 © Florian Holzherr, p. 55 © Ari Magg,
p. 126–128 © Terje Östling, p. 147–148 © Franz Wamhof

Copyediting by Matthew Gaskins
Designed at M/M (Paris)
Typesetting by Vera Selitsch

Production by Printmanagement Plitt, Oberhausen
Printed by Offizin Andersen Nexö, Leipzig

Published by
Verlag der Buchhandlung Walther König, Köln
Ehrenstr. 4, 50672 Cologne, Germany
Tel: +49 221 20 59 6-53
e-mail: verlag@buchhandlung-walther-koenig.de

Die Deutsche Bibliothek CIP-Einheitsaufnahme
Ein Titelsatz für diese Publikation ist bei
der Deutschen Bibliothek erhältlich

Printed in Germany

Distribution outside Europe
D.A.P./Distributed Art Publishers, Inc., New York
155 Sixth Avenue, New York, NY 10013, USA
Tel +1 212 627-1999, Fax +1 212 627-9484
www.artbook.com

ISBN 978-3-86560-335-7

Olafur Eliasson

Hans Ulrich Obrist

13

— The Conversation Series

Verlag der Buchhandlung Walther König, Köln

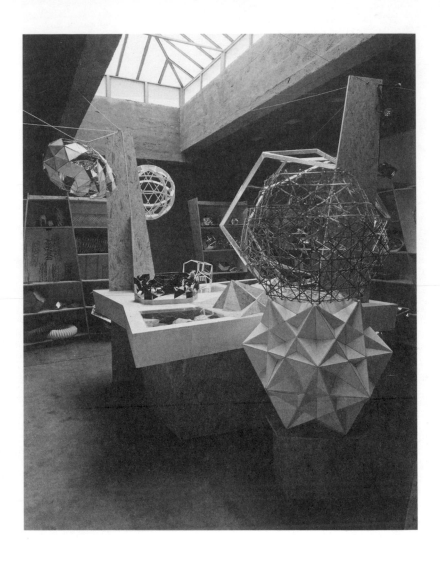

Model room, 2003, installation view at Tanya Bonakdar Gallery, New York, 2003

I — The interventions
Artist Studio Berlin, January 2003

Hans Ulrich Obrist — Let's start by talking about your work *Green river*, in which you completely changed the appearance of certain cities by coloring their rivers green [Bremen, Germany, 1998; Moss, Norway, 1998; The lower Fjallebak route, Iceland, 1998; Los Angeles, U.S., 1999; Stockholm, Sweden, 2000; Tokyo, Japan, 2001]. A good example was Stockholm, where you had an International Artist Studio Program [IASPIS] residency. How did people in Stockholm react?

Olafur Eliasson — At the time, I was working on a smaller project, but very quickly the idea of coloring downtown Stockholm became something I simply had to do. I bought the pigment, called uranine, in Germany and carried it back in my suitcase, through customs. It was a funny feeling—not that it was illegal to do this,

but there was a lot of suspense involved in bringing back enough pigment to color all of central Stockholm green. We hadn't told anybody about the project; it wasn't official, and there weren't any invitations. Because it was a hit-and-run project, so to speak, we put a great deal of effort into the planning, doing some measurements of the water and turbulence for a few days. We'd throw small pieces of paper into the water and walk along the river to measure the time, and the amount of water going through. We also determined where all the surveillance cameras were in the city, which may seem somewhat drastic, but if you think about it, it's really hard not to get filmed in downtown Stockholm. And at one o'clock on a Friday, I walked out onto the bridge with an assistant and we stood there with a shopping bag full of pigment. There was a traffic jam, so there were cars right next to us while we were standing on the sidewalk and pretending to stare at the water. This was the moment I wanted to do it: there were no other people around on the bridge, just all these cars that were not moving. But I became increasingly nervous because it seemed that the people in the cars were staring at us thinking, "If those two guys with that large, strange-looking bag do something weird, I'll call the police." After what seemed like an eternity, I thought, "What the heck, I'll just do it!" The powder was red, so when I emptied the shopping bag over the railing, a large red cloud appeared in the wind. Now, it may have been my imagination, but I had the feeling that everybody took their foot off the gas pedal at the same time and all the cars suddenly became very silent. Obviously, I was nervous, since this big red cloud was floating

over the water, sort of like a cloud of gas. And when it settled on the water, carried by the wind, the river turned completely green—like a shock wave. I had made sure to have the wind in my back. There was a full bus right there ten meters away from me, and all the people in it were looking at the water, then at me, and then back at the water. So I said to my assistant, "Let's walk away really slowly, as if all of this were very normal." That's what we did, and I threw the bag away in a garbage can—properly, as if coloring central Stockholm green were part of my daily routine. Eventually, we just walked into IASPIS, where I washed my hands. When I came back out, my heart really jumped, because the whole stream was green and a lot of people were stopping to look at it. It was amazing. The story ended the next day when the front page of the newspaper showed the river and the headline read "The River Turned Green." There was also a small article saying that some people had called the police, but were told that the color had come from some heating plant and was not at all dangerous. It was interesting to see how the press reacted to this. There's something about Sweden always being able to come up with the right answers to reassure people. Finally, I should add that the pigment was absolutely harmless and there was no pollution whatsoever.

Hans Ulrich Obrist —— **Would it be fair to say that *Green river* was about making the city and the act of seeing visible?**

Olafur Eliasson —— Yes. And maybe this is what the other *Green rivers* are dealing with as well. We all have a picture in our minds of our city and a picture of the water in the

city, just like the water of the Spree River in front of my studio's window, and my idea is to explore whether we see the water as a dynamic element in the city—like transportation, for instance—or as a static image. Is it real, or is it a representation?

Hans Ulrich Obrist —— There's a connection between what you're describing and a book and embroidery project by Alighiero Boetti and Anne-Marie Sauzeau-Boetti called *The Thousand Longest Rivers of the World* [1976–82], which is about the possibility and impossibility of measuring rivers. With this in mind, I was wondering to what extent your project was planned and to what degree you could predict what was going to happen? Which part of the *Green river* project is unpredictable?

Olafur Eliasson —— That's a good question, because if it had rained, for instance, the water level in the stream would have been higher, and there's a dam that controls the amount of water flowing through, which has an impact on the turbulence. I could have asked the people who operate the dam when they let more or less water through, but I was more afraid that the water would flow the other way or not at all. And then, of course, I couldn't predict how people would react—whether a riot would break out in downtown Stockholm, or whether the government would instantly close off the waterfront. But my experience has shown me that usually very little happens. As I said before, the city as such is more an image and not a space where interaction or action is practiced.

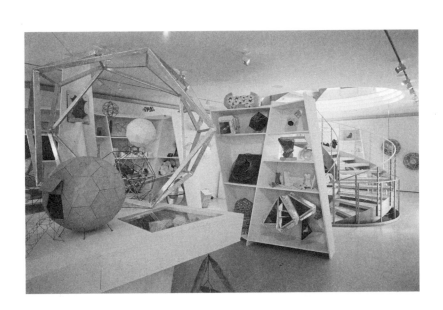

Model room, 2003, installation view at Kunsthaus Zug, Switzerland, 2004

Hans Ulrich Obrist —— Looking at the paper one day later, what strikes me is that this image is without authorship. Was the anonymity of the event important to you?

Olafur Eliasson —— Yes, in this case it was, since I was more concerned with the expectations and memories of the people in the street. In Canada, I made a project where I put chalk on the street using a small machine [*Proposal for a park*, 1997]. It was the kind of machine used for putting chalk lines on football fields, and my aim was to shift the map of the city by painting a new map of it directly on the ground. Of course, the chalk would have eventually just disappeared with the wind or the first rain, but the organizers of the event put large signs on the sidewalk advertising that this was art, so the piece never really worked. In other words, by limiting people's experience of the piece—by culturally coding it as art—it was formalized. A certain way of seeing was promoted that turned my chalk lines into paintings rather than potential adjustments to the streets.

In any case, with the green river on the cover of the newspaper, it worked differently. This was not conceived as art, and the themes that *Green river* dealt with differed from what they would have been had the river been perceived as an art project within an institutional practice with secure representational distance to urban reality. Of course, the institution is still—or, rather, always—there; it's just tilted slightly, so now I can say that the article is a part of the piece. The fact that a number of people actually called the police shows that what they saw was not a representation.

Hans Ulrich Obrist —— Or it may have been taken as something extra-terrestrial, in the same way Orson Welles managed to have people believe that UFOs had landed in the United States. As the rumor spread, it led to mass hysteria. So it was true for a certain time—it was people's reality!

Olafur Eliasson —— Yes, that's great—it's what I have to do next! I have to invent a rumor like that. But it's funny to see how the possibility of spreading rumors in the city is disappearing; we don't have the social corre-spondence between the levels, groups, or places where people with different social purposes interact.

Hans Ulrich Obrist —— It would have to spread through e-mail.

Olafur Eliasson —— Exactly—and it will grow much more. But what's really interesting about the internet is that we have a space with a different concept of time than we normally know it. The limits of time have dis-solved into a spatial relation, and the ability to relate to someone elsewhere is not hindered by the time it physically takes to go there—to Asia, for instance—but can happen instantly. And therefore time becomes internal; it passes different for you than it does for me. It's becoming less and less measurable; it's less objec-tive. Duration is inside us, and I think it's new that we relate more individually to the idea of time. So, the internet is not a direct translation of our everyday lives, but rather a whole new condition of space.

Hans Ulrich Obrist —— Does this mean we have a permanent present?

Olafur Eliasson — I guess we've always had that—anything else is impossible, at least when we look at the world from a subjective point of view. It interests me, and it's something I'm working on. The sense of past, future, and time has, by definition, been taken for granted as the fourth dimension of space, and as I mentioned before, I think this is too simple—and something we're slowly coming to realize, in part thanks to the internet. I think there's a stronger sense of time you could describe not as past and future, but as memory and expectations—as my time and your time. Before, it was always about the here and now, about space and time as a convention. Now, however, it's more about how you and I construct a here and now for ourselves. Time is not measurable—it's now. When I talk about *my* memory and *my* expectations, meaning *my* past and *my* future, I do this now, and when you think of it, this then becomes part of *your* now—of *your* memory, *your* expectations, and *your* world. I came up with a title for a book I'm working on about nine process-related works: *My Now Is Your Surroundings*.[1] This is what I mean.

Hans Ulrich Obrist — **You've done interventions in many cities.**

Olafur Eliasson — Often when I work on site, I don't have a very clear idea at the outset of where the project will ultimately lead. I develop the idea mostly as I go along, and I guess the one thing guiding me is the question of how viewers see themselves in a given space. It's basically a very open formula for almost all of my work. So with *Green river* I tried to pick very

(1) Jan Winkelmann, *Olafur Eliasson: My Now Is Your Surroundings—Process as Object* (Cologne: König, 2001).

different notions of the river in the city: in Moss in Norway, it was a very small, intimate setting. There you could say it was almost working with a Romantic notion of what the water was doing in that space. In Los Angeles, where the river is almost sacred because the city is located in a desert, the notion of water is completely different than it is, for instance, in Stockholm. So clearly it's relative. In Los Angeles, I did it as an action with a few people watching, and I felt sure that I was either going to have lots of police and problems or nobody would care at all, and it was the latter that was the case: nobody paid any attention. I did it in Iceland as well, out in the countryside: I wanted to see it both in an artificial and in a so-called natural environment—to research what a river does to a city or a landscape. It was interesting: when the water in the Icelandic countryside turned completely green, it looked like a picture, a representation. I thought I could make the landscape even more real—or hyperreal—through the impact of the color. In a city, the color green somehow takes the already representational image of the city and turns it around, making it, strangely enough, very real.

Hans Ulrich Obrist —— **Some people feel your work is related to nature, but the river is more of a hybrid between nature and artificiality, isn't it?**

Olafur Eliasson —— Definitely. What is nature, anyway? And who really cares about this constant search for the boundary between culture and nature? If there is a nature, I arrive at it through the people who are there

and their idea about where they are. If there aren't any people, so-called nature doesn't interest me.

Hans Ulrich Obrist — **When did you start doing things outside of the institutional framework, such as clandestine interventions in public space and without a commission?**

Olafur Eliasson — I think I needed it to avoid formalization. The work I do is very dependent on people being involved in one way or another. At some point, the shows inside institutions run into the barrier of commodification—a commodification of seeing and even of thinking. Since my work is very much about the process of seeing and experiencing yourself rather than the actual work of art, it's problematic when your way of seeing is formalized through institutional structures—rather than your being encouraged to question your perceptual set-up. So working outside with improvised interventions represents a desire to dissolve my work formally and to unmask the formalizing power of institutions—and, of course, to engage the audience.

Hans Ulrich Obrist — **What was your first intervention?**

Olafur Eliasson — One of the first ones was at the Johannesburg Biennale in 1997. I had been invited to contribute a photo series. However, the fact that I was showing these photos gave me a feeling of—how shall I put it?—standing outside the society; the photos were too autonomous as a work. So when I got there, I immediately knew I wanted to do something else as well—something that, without being opportunistic,

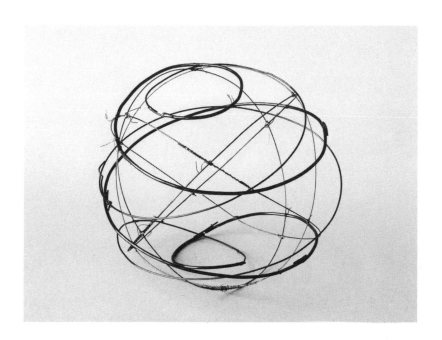

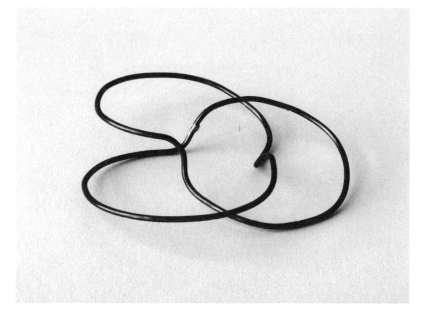

Models 1996 – 2003

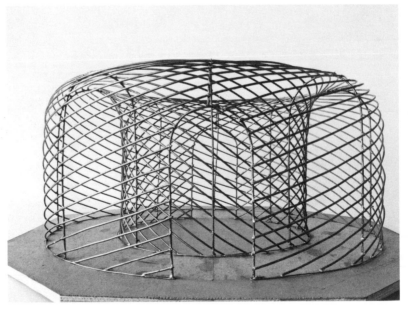

Models 1996 – 2003

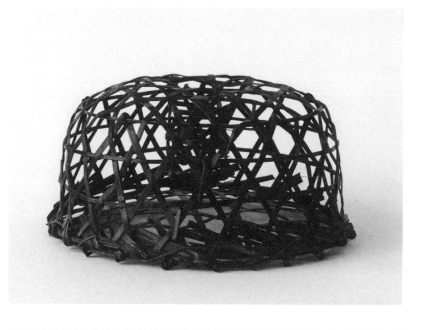

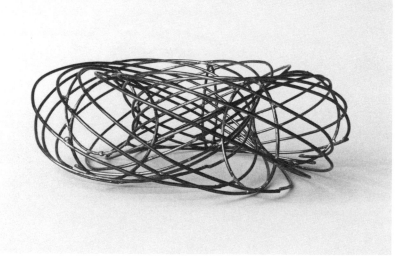

Models 1996–2003

Models 1996–2003

Models 1996–2003

would also question the situation of the local institutional framework. That's when I saw the small rainwater reservoir that eventually turned into the Erosion project [*Erosion*, 1997]. I found a person who could help me, and I made the project before the opening of the exhibition so it would be even less a part of the institutional framework. The curators and people at the Biennale didn't know that I had done it until halfway through the project when the water was running all over the place.

Hans Ulrich Obrist —— **What did it look like, exactly?**

Olafur Eliasson —— I emptied the water out of the reservoir. It flowed for one and a half kilometers through the city like a small river. It looked wonderful—very simple and poetic at the same time.

Hans Ulrich Obrist —— **At the Biennale in São Paulo, we were inside and there were many art visitors skating on your piece [*The very large ice floor*, 1998], and on the other side, outside, actual skateboarders were using its margins. The two audiences kind of met without really meeting. What did you think of this encounter?**

Olafur Eliasson —— Well, maybe it actually moved them even farther apart from each other—or at least exposed the distance between the people in the exhibition and the ones outside. The distance between the two groups was made bigger due to the glass of the window separating them. Who is it that talks about losing the tactile relationship to our surroundings, about keeping just a picture of it? I think it's Richard Sennett.

22

He suggests that by putting up glass and isolating people's tactile relationship to the outside, our overall relationship to the outside changes—the sensation becomes more representational. The modernists believed that glass opened up the border between the inside and outside, but in fact I believe the opposite is true: the border was exposed even more clearly, as were the social differences between those who were inside and those who were outside. And by isolating only some of our senses, such as those of sound and smell, from the other side, the glass creates an image that's not unlike a very realistic movie. We know the outside is there, but our engagement is slightly more representational. I would argue that there's a proportional relationship between how many senses are engaged and the level of representation.

This is something I was trying to work with in São Paulo: the notion that people outside the pavilion become an image or representation when looked at from the inside and vice versa. The people who didn't pay the entrance fee and stayed outside looked in at the exhibition and may have said, "The people in there think the floor is a work of art, but in fact it's just ice, and the image of them walking on it is the actual work of art, seen here from the outside." So among other things, my idea was to work with the glass as a soft border between reality and representation.

Hans Ulrich Obrist — **So maybe it's similar to a litmus test for reality.**

Olafur Eliasson — Ah, that's a good one. I should use it as a title: *A litmus test for reality* [*laughs*]. But to return

23

to my ideas about reality and representation: if we listen to a walkman when going down the street, replacing the sounds of our surroundings with music, the experience of the street changes thanks to this "soundtrack"—it gains a form of narration. If we're familiar with the particular street, such as 5th Ave in New York, from films, the narration can be more extreme and the level of representation even higher. At the Carnegie International in Pittsburgh, most people looked at my column of steam [*Your natural denudation inverted*, 1999] through a window; only very few of them actually walked out into the museum courtyard to look at the work from the outside. And I ask you, how can you look at an outside steam project from the inside? Well, it's very easy—you just look through the glass. But in doing so, you don't hear the sound and you don't have the sensation of pressure and suspense from the steam pipes, the wind and temperature in the museum court and so on. And this is what I mean: the window, in a museum in this case, is always like a picture frame, and you look through the frame to see a picture of the picture of the picture of the picture. And, most importantly, I believe that we are able to orient ourselves within these levels of representation. It's very important to understand that I'm not trying to moralize about this. It's not about Romanticism, and I actually believe that my generation is the first to really understand how to orient itself within these levels. It's extremely important for us to be aware of sliding between the levels—to be aware when putting on a walkman that it's not the sound of the street we're hearing, but the music of the walkman. Or when looking through the window at the steam at

the Carnegie Museum in Pittsburgh, that we aren't feeling or hearing the pressure of the steam nozzles, but rather the sound of the museum shop behind us, which makes the steam more abstract and movie-like. If we're aware of what our senses are telling us about our surroundings, we can orient ourselves successfully. But if we're mistaken about what we sense and believe that looking at the steam from the inside through a window is a comprehensive experience of the steam, we have a problem. It gets worse if we believe that the music from the walkman is the actual sound of the street or that driving a large jeep is the same as hiking in the mountains. This is why it's so important to see ourselves sensing things or to sense ourselves seeing— to survey our experiences from a sort of third-person point of view—from a double perspective.

Hans Ulrich Obrist — This leads me to another question—one about the relationship of your work and thinking to architecture. When you work on exhibitions, inside or outside, there's a link to space that's also architectural in nature. You went to art school, but you didn't study architecture, did you?

Olafur Eliasson — No, it happened naturally. I was working with the notion of the spectator from quite early on. I tried to argue that I was just creating a non-mystical machine and the piece would really be the field between the spectator and this machine. The gaze of the spectator constitutes or creates the piece in a complex way. This meant I thought a lot about questions like: what is a space, really? And, more importantly, how do we orient and understand ourselves in a space? This is how I came to architecture, by realizing the fact

that architecture is not the shell, but something that adjusts itself according to what's going on inside—or outside, for that matter.

Hans Ulrich Obrist —— For me, the first time your proximity to architecture really became visible was in your piece for *Manifesta I* in Rotterdam [*By means of a sudden intuitive realization,* 1996], where suddenly there was a link to Buckminster Fuller through a very special experimental tent structure you collaborated on with Einar Thorsteinn.

Olafur Eliasson —— At that point it was still a contained object, even though I tried to integrate the *Manifesta* piece into the garden behind the museum. I had never thought of this project as the beginning of my interest in architecture, but maybe you're right.

Hans Ulrich Obrist —— Could you tell me more about your dialogue with Einar? It seems to be a very important and long-term dialogue for both of you.

Olafur Eliasson —— Yes, he is very inspirational, and he supports me with his great knowledge of so many things. It's hard to say, because we disagree on many things as well, and we often have intense discussions. But, as an introduction, I should point out that he studied and started working with Frei Otto in the late sixties. Then he worked a bit on very diverse things, getting to know a wide range of great people such as Buckminster Fuller, who wrote a preface for a children's book that Einar made on geometry in the seventies. I first met him some years ago when I needed someone who could calculate a complex geodesic structure I was

working on. And since then we have become friends and worked together on many things.

Hans Ulrich Obrist —— You mentioned earlier that the generation of artists that emerged in the nineties has often shared this doubt about the object. There seems to be a very interesting parallel with the architectural references that crop up in your work. You've talked about Buckminster Fuller before and also about Frei Otto, etc. These are all architects who are not about the object, not about occupying space, but rather—as Buckminster Fuller put it—about a service, a relation. It can appear or disappear. What do you think about this link between artists of this generation and these architects and urbanists—Yona Friedman or Cedric Price are other examples—who weren't so much about the object and who actually questioned the notion of the building as a permanent thing?

Olafur Eliasson —— Just as the dematerialization of the art object has become relevant again over the past ten years, so too has the decentralization of the objective modern space towards an understanding based on a non-central perspective. It's important that this new understanding is not a new model replacing an old one. We have now realized, I believe, that we can't criticize the modern idea by having a new one replace it—that would just bring us back to the start. For me, this is partly why I enjoy some of the more utopian architects and thinkers, with their ability to reflect upon their own vision from the outside.

Hans Ulrich Obrist —— But this, again, seems to have something to do with our generation, and that leads me to a question I wanted to ask you before about the differences you see between now

and the sixties or seventies—not only in terms of technical differences, but also in terms of this seemingly seamless oscillation between inner and outer institutional practice.

Olafur Eliasson — Do you think institutions today are opening up like that? Perhaps a few are, but in general I think it's very rare that inner and outer practices are joined. Artists may be mixing these practices, but the institutions are following their lead. They seldom take an active role in these relationships.

Hans Ulrich Obrist — **Do you see yourself as an infiltrator—as somebody who infiltrates the institution?**

Olafur Eliasson — If you mean my infiltrating the subject—the spectator or interpreter and how they see themselves in the institution—then yes. The institution, or let's say the museum, only really exists as a construction, and it's always changed or infiltrated with every show in one way or another. I believe the audience has much more power than it's actually allowed to exert. Too often, museums pacify, rather than activate, audiences. Even after so many years of criticism, institutions still commodify thinking or objectify seeing with their repressive way of communicating.

Hans Ulrich Obrist — **Does the spectator do fifty percent of the work?**

Olafur Eliasson — Yes, if they're allowed to—and this interests me. Visitors or spectators are engaged in a certain situation, and if this situation is activating, they see the situation engaging back, so to speak. Obviously the situation doesn't actually react back at them, but they,

through a constructed third person, see themselves seeing. I don't think this is new at all; it's the same in the illusionism of Baroque painting—everybody knew it was a painting, not a ceiling going all the way up to God with plenty of fabulous angels on the way. Everybody was supposed to know that it was an illusion; otherwise it wouldn't have been fantastic, but just a very high building. And through this notion of double perspective, you relate to space: you see it, you walk in it, or you act in it, and the space has the ability to show you that you're doing this.

Hans Ulrich Obrist — **So the space corresponds to you in a way that you see yourself doing this.**

Olafur Eliasson — It's like a reversal of subject and object: the spectator becomes the object, and the surroundings become the subject. It's thus endlessly seamless, so to speak. This is why I try to make the spectator the exhibited part—the part that's in motion, dynamic, and engaging—and pretend that the architecture and the situation are the subject. It becomes increasingly complex. An example is the show I did in Tokyo: there was a strong lightshape projected onto the wall [*Your blue/orange afterimage exposed*, 2000]. When you looked at it, it caused an afterimage on your retina where the projected light used to be; the afterimage was the complementary color. After that, you would see the afterimage for a minute or so, no matter which direction you looked. So then suddenly you were the projector—you were the one projecting the image onto the wall. The person became the machine, and all the projectors became the spectators.

Hans Ulrich Obrist —— The inside becomes the outside, and the object becomes the subject.

Olafur Eliasson —— Exactly, but of course it doesn't stay like this—it darts back and forth: subject, object, subject, object. I think this can be used as a quality; it can be something positive and productive.

Hans Ulrich Obrist —— Is this a new situation?

Olafur Eliasson —— Well, in a way, but it may not be all that new. We always used to look at a map if we couldn't find our way around a city. Now the map is part of the city, and you can either experience the city guided by the map and just be on the map, or you can go into the city and just be in the city. The map is not better or worse than the city; it just has a different representational level. The problem arises when freedom is limited—when you're told that the map is, in fact, the city, or the city is the map, and you then believe this. Like at Potsdamer Platz in Berlin, where it's suggested that you're in a real situation, but in fact it's very representational—you're displaced, as it were. So I don't think our being displaced like this is new, but our being able to reflect upon it and understand the mechanisms this way certainly is.

Hans Ulrich Obrist —— This leads me to a question about virtuality. Jonathan Crary talks about virtuality in your work—not in the sense of virtual reality, but of a dimension of the possible.[2] Do you agree?

(2) Jonathan Crary, "Olafur Eliasson: Visionary Events," *Olafur Eliasson* (Basel: Kunsthalle Basel, 1997).

Models 2004–2006

Models 2004–2006

Olafur Eliasson — To me, virtuality is connected with inter-activity—not interactivity in a "press the yes or no button" kind of way, though. Until a few years ago, the feeling of the virtual was so representational that you could only relate to it as a sort of grid. I think this has changed now. Today, virtuality means inter-activity in the sense that if you engage, the virtuality changes. And, perhaps more importantly, as you do that, you change as well, because you've taken it upon yourself to engage, to interact. The double perspective is acknowledged by the virtual space. The important thing is that virtuality should have an impact on you, just as you should have an impact on it. As a result, it contains a certain unpredictability.

Hans Ulrich Obrist — And what about e-mail, for example? Has e-mail changed the way you work?

Olafur Eliasson — E-mail has certainly changed something about our understanding of time and fluidness, but it represents a natural development of a process that was already taking place.

Hans Ulrich Obrist — There's another question I'd like to ask—one I ask in every interview. What are your favorite unrealized projects? It's a very broad question. The projects could be ones you wanted to do but forgot about, ones that would have been too big or too small to realize, or utopian projects or projects that were censored or proved impossible within a particular institutional framework.

Olafur Eliasson — I think my life in general is an unrealized project. That's the bottom line. I've tried to work with

anti-gravity; it started with Euclidean geometry, then the relativity of Einstein, and later I was looking at Niels Bohr and the fact that when you measure something, you've already changed the thing you've measured, and so on.

Hans Ulrich Obrist —— I love the text where Crary writes that your work escapes all form.

Olafur Eliasson —— Yes, I suppose so—like the strobe light, because gravity is perhaps only something we imagine. If we didn't know about it, we might not even be sitting here on the chair, but flying around while talking.

Hans Ulrich Obrist —— Are there any concrete unrealized projects that were commissioned but were too expensive, utopian, or grandiose?

Olafur Eliasson —— Definitely, a lot. To return to the idea of anti-gravity, you can take a plane and let it drop from one altitude to another, causing a free fall, and for a short time you have a non-gravity situation inside the plane. For a show, I once proposed taking people on a flight like this to study the phenomenon, but it was never realized.

Hans Ulrich Obrist —— Where was this?

Olafur Eliasson —— In Saint Louis. It's something I still hope to do. Once, I tried to dam a harbor and empty the basin to build a sort of park at the base. It wasn't so much about the harbor, or the water, or what was under the

water, but rather about memory and expectations in terms of spatial relations. This is unrealized, as well.

Hans Ulrich Obrist —— For architects, collaboration has played a big role since the early nineties, and obviously there are also different forms of collaboration among artists. What's your take on collaboration?

Olafur Eliasson —— In a certain way, I think I always collaborate with others. The collaborative idea can be seen on various levels. With exhibitions, for instance, I'm lost if I don't have some sort of collaboration with the curator or other people involved. In fact, I'm more responsive to the people in any given situation than I am to a specific environment. I never do a project if I haven't spoken to somebody about it first. It's just not possible. I rely very much on the people who help me in my studio all the time.

Hans Ulrich Obrist —— This leads to the question about your collaboration with architects. It seems to have become a more important aspect of your work recently.

Olafur Eliasson —— Yes, I've started to work much more with architects—not just for commissioned work integrated into architectural projects, but also by involving various architects in my own practice. The field of architecture is changing very rapidly, and I find a great deal of inspiration in this. In the same way that artistic practice has rediscovered its ability to constantly re-evaluate its own platform, architectural discourses have opened up a bit, engaging in matters other than their own formal setup. This is why including

architects—and engineers or scientists—is crucial for bringing me to places I couldn't reach on my own.

Hans Ulrich Obrist —— I think that's a nice conclusion. Thank you for your time, Olafur.

II — The weather project
Artist Studio Berlin, January 2004

Hans Ulrich Obrist —— I'd like to speak about *The weather project* [2003], your installation for the Tate Modern's Turbine Hall. I had the impression that your work on it was very focused and intense. Whenever we've spoken or seen each other over the past year, you were doing research, and I understand that it involved more research than any other project you had worked on before.

Olafur Eliasson —— Yes, but it's surprising how few of those research elements finally made their way into the exhibition, especially considering the vast amount of information that we collected. The research it required isn't necessarily visible.

Hans Ulrich Obrist —— Since the opening untold numbers of people from vastly different backgrounds and walks of life have flocked to the Tate to see the piece. Did you imagine this would happen?

Olafur Eliasson —— No, of course not—not at all, in fact. I was quite surprised, and I think it's the result of the symbiosis of such a very, very big city, a mega museum, and—if you will forgive me for saying it this way—a mega art project in the sense of its physical scale. And then there was also a really broad interest from the press—a very large percentage of which was not the art press. A great deal of coverage took place in weather reports, for instance. The weather reports in many countries and, of course, mostly in England, mentioned the work, and weather reports are among the most-watched programs on TV. I guess they were really happy that someone was finally doing something in their field of expertise. At any rate, this vast media attention, along with the city, the big museum, and the scale of the piece—these really came together to bring the project to people's attention. So it's not only the artwork itself, but also the combination of these factors that contributed to its success.

Hans Ulrich Obrist —— I know a beautiful text by Roni Horn on the weather; she actually read it at the memorial of Felix Gonzalez-Torres. It's about the dimension of weather in his work.[3] Aside from that text though, the weather has been a neglected theme in art, even though one might be able to describe it as a medium in art. Molly Nesbit and I had a discussion a few months ago with Rosalind Krauss in Paris to follow up on her

(3) Roni Horn, "An Uncountable Infinity (For Felix Gonzalez-Torres), 1996," *Roni Horn*, Louise Neri, Lynne Cook, and Thierry de Duve, eds. (London: Phaidon, 2000), 120–123.

book on the post-medium condition, and we spoke about Ed Ruscha. Ed Ruscha is perhaps less a painter or photographer, and his medium is perhaps not so much painting or film, as something else entirely. Many things Ed Ruscha has done are related to the perspective of the car. Thus, perhaps we could say that his medium is the car. In relation to this, I wonder if one could say that your medium is, in fact, the weather.

Olafur Eliasson — Well, I think my medium is people, and I actually feel that, to some extent, Ed Ruscha's work is also about people. Cars are like robots: they say something about people. Without people, cars would not be able to drive anywhere. And a robot is only interesting because you know something about people. This is maybe the case with Ruscha, too. But, actually, I think the weather has some great advantages over the car, such as its mundaneness. It's something that everyone tries to come to terms with in the most unspectacular and simple ways—like putting on a rain coat on Wednesday and putting on sunscreen on Thursday. The weather, in all its shades, is really about tactility. It is, in an odd way, about mental tactility—trying to imagine something—but also about "Oh, I got wet" or "I'm cold" or "I'm sweating." It has these really physical aspects, but it's also physical on an intellectual level. When you think about the cosmological potential of weather, it becomes almost physical. And yet, the weather also holds unbelievably profound questions: what is time? What is unpredictability? What is chaos? What is the turbulence of our atmosphere and universe? In other words, the weather also incites some very large, existential questions. And

there are not too many things you can actually say this about. That's what I like about it.

Hans Ulrich Obrist —— The catalogue reflects some of this broader research on the weather, which, as you said, shows itself only in small parts of the installation. Perhaps you can tell me more about the different kinds of research you did for the Tate project and also about research in general for you, which I think is crucial to understanding how you work.

Olafur Eliasson —— The research wasn't academic, in part because it was so open-ended. It involved coming to terms with factors that are obscure when you enter a big institution or even a small institution, including questions like: how much influence will the context have on your project? How do you negotiate that influence? How do you make that influence something progressive and full of potential? And this is why the research was complex. It was both classical and meteo-rological—about understanding what the weather is and, in particular, who is working with the weather, and in what ways and why people are interested in the weather. This involves a psychology of the city and of how people see the city, as well as environmental questions. And, using the same research, my idea was also to challenge and maybe even provoke the institutional grid. So part of the research was a kind of institutional evaluation rather than criticism. Institutional criticism is about something else.

Hans Ulrich Obrist —— Speaking of research, your studio has grown a lot since we last spoke. I remember that you used to have only two or three people working for you. Now you're at

the head of what one might compare to a mid-sized architectural office. At the same time, you connect to lots of outside sources for knowledge and research for each project. These include people you would not necessarily work with regularly, but they nevertheless form a larger network of collaborators. In this sense, you've set up something that goes far beyond a traditional art studio. Could you talk about the recent developments with your studio, also in relation to the Tate project? How are activities structured, what is the role of the individual versus the team, and what is the relationship of discovery to correction or to implementation and knowledge?

Olafur Eliasson — Over the past two or three years, I've come to believe in the relativity of discursive thinking. I've gained the confidence to challenge the idea that discursive engagement is linear; it's much more about constantly negotiating or challenging the situation you're in at the moment than it is about laying out a trajectory you subsequently try to follow. This means I've actually been able to engage many different opinions and also change my own opinion quite often—all of which has led to much greater success. I think there's so much more scope for inspiration and potential creativity in this approach. Let's introduce the taboo word "creative" again. I like the idea of taking in young people who bring great ideas, or old people or architects or scientists who come with their projects, their identities, their trajectories, and so on. What we have in common—and the only rule or key between us—is that everyone understands that what they say is not a universal truth but is always based on a construction. Someone might have something to say

Model room, 2003, installation view at Aedes am Pfefferberg, Berlin, 2006

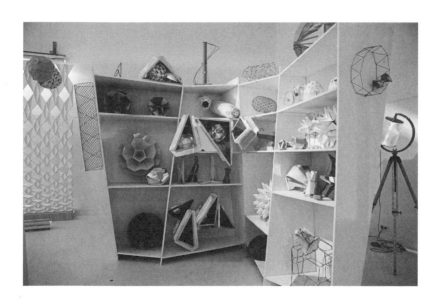

Model room, 2003, installation view at Aedes am Pfefferberg, Berlin, 2006

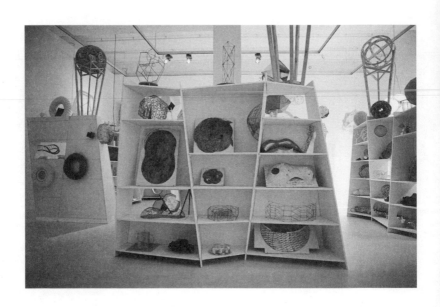

Model room, 2003, installation view at Aedes am Pfefferberg, Berlin, 2006

that is relevant in a certain context at a certain time, but there is no hierarchical system of truth. To speak a bit about creativity is also to recognize its great potential. The world today is so unbelievably egoistic, racial, and extremely aggressive, but creativity can work against these things, since it's unpredictable and can't be locked down. So if you look closely at *The weather project* for the Tate, it has the potential to become a danger to society. Creativity is not about formalization; it's about action, individuality, and believing in things.

Hans Ulrich Obrist —— In a recently published interview, I asked you about the spectator and participation.[4] You explained that, for you, spectators do at least fifty percent of the work whether they are aware of it or not, adding, "Visitors or spectators are engaged in a certain situation, and if this situation is activating, they see the situation engaging back, so to speak. Obviously the situation doesn't actually react back at them, but they, through a constructed third person, see themselves seeing." This is very nice—it almost anticipates the Tate piece. Can you speak about spectatorship in relation to *The weather project?*

Olafur Eliasson —— I think participation is fundamental. Time is basically constructed through participation. Non-participation is also a kind of participation, or a statement at least. But I think what we're dealing with is what I sometimes call "looped participation," or participation where there is an evaluation of itself as participation. Participating is no problem— going into a shop and buying something is a kind of participation—but it doesn't usually involve

(4) Thomas Boutoux, ed., *Hans Ulrich Obrist: Interviews* (Milan: Charta, 2003).

evaluation. I think this is the potential of cultural activity. I think of great literature, some great music, and especially the theater this way, too. Through these, you can model participation and introduce evaluation as an active element in the participation. The problem is, some museums simply don't *empower* the visitor; they're critical and aware and programmatic, but they don't always allow people to participate with that element of empowerment: to participate and engage at the same time. But the empowering element is an institution's ethical responsibility.

Hans Ulrich Obrist — In relation to this discussion about the limits of the museum framework or a given art context framework, it's interesting to point out how unique the conditions were for the Tate project, both financially and in terms of the time you were given for it.

Olafur Eliasson — One thing I should mention is that a lot of my pieces, if seen together, cover different architectural or spatial issues. I think it's possible to view my work as a house, a living unit, or a domestic idea that challenges objecthood, objectivity, and formalism. So in this way I see the progression of my work as an evolutionary development: the development of my studio, the trajectory of what is next and how to proceed. I can see how some of the parts I'm working on can come together as a kind of city—not only because I've made a stone floor as an artwork or any of these literal examples, but in terms of an open-ended philosophy. This is one way of thinking about it, but I'm also trying to become

involved in projects that constantly challenge the time concepts of the institution. I've tried to keep the projects open and to remember that institutions have an impact on you whether you like it or not—a time grip or time grid, an exhibition schedule, as you say. But I have some ideas as well about different projects that I want to do: I would like to get a plot of land in Iceland and do something with it, but I have to understand how to do it, because to me it seems that James Turrell's *Roden Crater Project* [1989] or the outdoor projects that Donald Judd created in Marfa [Texas, USA] were reactions to the institution. These are great projects, of course, and both Judd and Turrell have paved the way for the art I make today, but I need a justification for doing something in Iceland that doesn't involve simply replacing one system or way of understanding the world with another.

Hans Ulrich Obrist —— **Your Icelandic project makes me think of utopia, actually, which is something we haven't really focused on before in our interviews. Of course, you participated in *Utopia Station* [50th Venice Biennale, 2003] with a piece that I can still see clearly in my mind [*Your utopia*, 2003]. I'd like to talk to you about this in relation to what you've just described, which seems to be about the social contract of art, in fact.**

Olafur Eliasson —— I'm very confident in art and, believe it or not, I'm very confident in people and social responsibility. It's just not paying off very clearly at the moment, but I am fundamentally optimistic. I think utopia was a very nice term for believing in what you're doing. However, people made the mistake of thinking

that, after utopia, there are no beliefs anymore. But time goes on, and we still believe that it's fundamentally better not to kill each other. And for me, utopia is still there. The idea that what I do makes a difference, matters, and is important: this is what used to be called utopian. When we spoke during the summer, I had the idea of utopia being something you project onto your surroundings. It's something within yourself and for which you say, "This is a situation I want to engage in"—and then you engage in it and generate life and time and yourself and other people. This, I think, is the new utopia—the "newtopia"—the way we produce our surroundings with our belief in the worth of what we're doing and the integrated evaluation and critique as we do it, as we said of participation before. That's why the discussions of whether or not utopia has ended or what it means are, in my mind, less relevant than the idea of your life as a product of systems, time, and society. I'm completely happy with calling it utopia.

Hans Ulrich Obrist —— **Maybe we can talk more about your project for *Utopia Station* because I think it's important to talk about the unrealized part I hope we can realize in the next step in Munich. The project brings together the idea of the house, but also the idea of participation—the active aspect that you were talking about—in the form of a small factory of special stones or bricks that visitors can use to create their own house or urbanism or even a do-it-yourself city in a Yona Friedman kind of way.**

Olafur Eliasson —— I very much like the idea of producing your own surroundings, your own life—the building blocks for a house, or structure, or even a sculpture.

For Venice, for *Utopia Station*, I liked this notion of producing bricks the way they did in the second half of the eighteenth century. Of course, it's completely different today—there are no reoccurring systems, but there's still the same commitment or belief in the worth of doing things. And this is what I think *Utopia Station* is about. It's much more about being convinced than trying to stop things. Of course, a utopia is internal. Becoming convinced happens very differently for each person, so in the end it's an individual utopia. Thus, I would never build the same unit as you, and you might take a brick and do something completely different with it. But one should not think that *Utopia Station* as a structure does not have any formal challenges. I think there are examples of similar ideas that one has to integrate into *Utopia Station*, such as proposals from the sixties and seventies based on action, social calls, and social relationships. *Utopia Station* has to renegotiate or rechallenge some of these projects in order to avoid looking just like one of them. I think this is the real challenge of the next manifestation of *Utopia Station*.

Hans Ulrich Obrist — **Do you mean *Utopia Station* should be more historical?**

Olafur Eliasson — Well, maybe this is a bit too formal. But I think that if people walk into *Utopia Station* and say, "But this is like Sonsbeek [sculpture exhibition in Arnhem, Holland]," then it loses some of its force because it's like putting a representational filter in front of people. They don't see what it actually is because they think it looks like something else. We

need to show people that this is indeed related to Sonsbeek, but a better way to word it is to say, "If Sonsbeek had never existed, there might never have been a *Utopia Station*." And this is what I mean by showing all the wheels. To a certain extent I feel that involving the older artists was a solution, but I'll admit that I'm not entirely sure what the best way is to meet this challenge.

Hans Ulrich Obrist —— **Let's talk about public art.**

Olafur Eliasson —— I'm not afraid of public art because it's not as context-based as some other ways of exhibiting works. When you show in a gallery, you're quite concerned with what came before and what will follow in the gallery program because there's a certain overlap in ideology. So if the shows before and after yours are nonsense, then your show takes on that agenda, whether you like it or not. The case is different with public art because, like architecture, it has been extensively compromised. But I see a great potential for art in public space because there's always the possibility that people might not realize that it's art. It's as simple as that. People might enter a plaza and think a piece is something functional or something they don't understand, but it's there. And this intrigues me—the fact that such pieces are not immediately recognizable as art. Of course, that would bring limitations to the engagement and participation we spoke about before, and I see many other problems, too. But I can see those problems in every field and every situation.

Hans Ulrich Obrist — Can you give a few examples of projects you've realized in public space?

Olafur Eliasson — I've worked with integrated lighting in a façade, incorporating very subtle light into an office building in Munich—a typical public art project [*Untitled*, 2002]. In another case, I worked with the illumination of a subway tunnel system in St. Louis [*I only see when I move*, 2001], where the colors of the illumination were supposed to create particular experiences for the people sitting on the train and passing through the tunnel. This was a great challenge. I hope it worked; it was very interesting, even though St. Louis has a lot of uninteresting public art projects. So, in this way I see public art as an extension of the laboratory I have here. I have no problems with exercising spatial challenges or problems in public space. I'm also extremely keen on working outside of the art context. I don't think people outside on the street look at public art the same way that people within the art context do. I don't know if I should mention other examples—I also made a quite big sphere in a shopping center in Munich designed by Herzog & de Meuron [*Sphere*, 2003, in Fünf Höfe, Munich]. There, I really tried to make a strong spatial statement; it was a very sculptural project. I tried to introduce a different space based on the already existing space and suspended above people. So I think there's potential, but I actually haven't made so much public art, now that I think about it. I'm trying to do more at the moment, but nothing is finished.

Hans Ulrich Obrist —— Can you tell me about the two shows you have going on now in Reykjavik and Oslo?

Olafur Eliasson —— There are two new works in Reykjavik. One of them I have wanted to do for some time but could never realize. It's a simple piece in terms of technical material: a horizontal line of light that changes color very slowly [*Your activity horizon*, 2004]; it's a little like the round room we had in Paris [*360° room for all colors*, Musée d'Art moderne de la Ville de Paris, 2002], except it's a line going around in the space and is only five millimeters high, but sixty meters long. The space isn't round, so it goes along the walls. Then there's another work, which is a floor piece based on a three-dimensional tiling system. The show in Iceland also involves three older works, like the *Model room*, which you know, but also the Zome tools playing table [*The structural evolution project*, 2001] where you can build all the structures yourself, and it has two photo series. I had never shown photos in Iceland, and one series is a new one of houses in Reykjavik [*Reykjavik series*, 2003]. The hanging grid is a bit like the *Model room*, playing with how to present a grid. And the other is *The horizon series* [2002] that connects to the horizon line in a way. So there are five or six projects in all. The Oslo show, on the other hand, will focus on some works that I've shown less frequently as of late—works that try to challenge our conception of space by using light and color as the primary media. The architecture of the Astrup Fearnley Museum is traditional—a collection of white cubes or traditional galleries. The idea was to see whether our relationship, as spectators, with art could

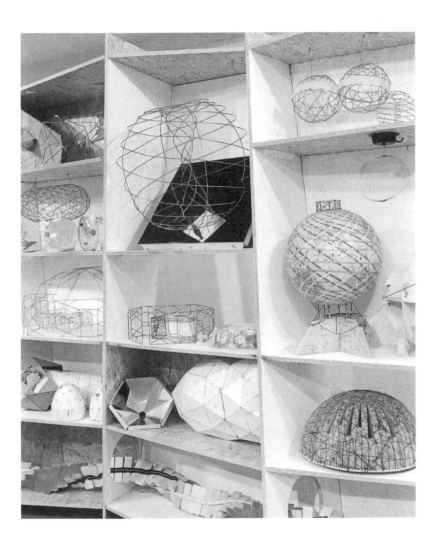

Model room, 2003, installation view at Reykjavik Art Museum—Hafnarhús, Reykjavik, 2004

be evaluated or challenged by inserting lights and introducing lines other than the cubic, perpendicular lines of the Euclidean architecture the museum is based on. This means I've introduced a sequential experience of the exhibition and worked with a narrative, developing it by focusing on movement. The show, I would argue, will not be considered static, but may have some relativity. Depending on where you stand, the rooms can look very different.

Hans Ulrich Obrist —— **So there won't be one predetermined route through the exhibition but, rather, many forking paths?**

Olafur Eliasson —— There are several paths. But the museum is not very big so you don't have all that many choices. The round light room in Paris basically filled the space completely so you could go to the room through the door, but not in between the light walls and the actual walls of the space. The most complex installation is the one from Paris, but there are simpler ones, too, like the installation with a single mirror hanging from the ceiling and a light shining on it [*Tell me about a miraculous invention*, 1996]. On the wall behind the mirror, there's a shadow of the mirror, but then the light, which is not obviously in the place of the shadow, is projected onto another wall. So I try to deconstruct the space with very simple methods—not to confuse people, but to make it soft, negotiable, and tangible. But this is evident only if you move, only if you go around. There are quite general spatial questions raised in each space.

56

Hans Ulrich Obrist — I'd like to speak about your photographs, which are not mentioned very often in relation to your other work. You've actually taken quite a few photographs, and although they do appear here and there in shows, I've never seen a big exhibition of your photographic work. How important is photography to you? I'm particularly interested in the archival dimension and in how you classify your almost encyclopedic range of images.

Olafur Eliasson — The photographs evoke questions just as any image does. Every year, I focus on one or two or three topics—in Iceland in particular—and I try to document them. Two years ago, I traveled around the island and tried to collect as many horizons as I possibly could in a month or so. I consider that project a study in horizons. The horizon line obviously has to do with how far you can see before the sky meets the ground, but I think the horizon is also a wonderful, metaphorical topic. This documentation is ongoing, and in about ten or twenty or thirty years, if I can and want to continue, it will constitute a fairly substantial archive of different phenomena in Iceland. I have waterfalls, bridges, houses, crevices, fences, ice-blocks, horizons, caves, and islands, and at some point I'll consider it a kind of mapping or, as you said, an atlas. But it's not only the mapping of a country or even of a mini-continent, as I often call Iceland. It's also the mapping of images that create ideas. When I photograph a cave, I consider the geological aspects of caves because they are so unbelievably interesting. However, I think the ideas you get from looking at a cave are even more interesting still. It wouldn't be wrong to say that these photographs constitute a kind of sketchbook

of ideas for the projects I've been working on, because there's an overlap of topics. Actually, there will be a big photo show with all my works at the Menil Foundation this year [*Olafur Eliasson: Photographs*, 2004]—a survey of the collected series. There are, I think, thirty-one large photo series, each documenting a different phenomenon.

Hans Ulrich Obrist —— For my final question, I'd like to ask you about an edition project of yours I once saw the beginnings of. The idea was to map the whole of Iceland using found images.

Olafur Eliasson —— It uses found images, yes. The Icelandic Cartographic Institute used photos to make maps of the country. It started out as a military project at the beginning of the century, and it eventually turned towards research—geological research, volcanic research, etc. They photographed the whole country from above by plane. And these photos were made with an unusually good photographic system. What's interesting about this, besides the idea of mapping things completely, is that we are now in an era of satellite images, so aerial photography has disappeared. It would take a long time to explain this adequately, but, fundamentally, the airplane is only one kilometer up in the sky and that means that the view of one square kilometer of ground is completely different than the view from a satellite, which is 600 kilometers high. There's a spatial issue an airplane photo deals with that a satellite photo doesn't have to deal with. A satellite photo involves another conception of cartography; this is quite interesting because our eyes and the way

we relate to space are in a limbo between aerial and satellite perspectives. The map is also about that.

Hans Ulrich Obrist — How we see and how we perceive space—it's amazing how even your most seemingly dissimilar projects persistently explore that. Thank you for this interview, Olafur.

Hans Ulrich Obrist —— I'd like to start by asking you about this new structure you're creating here in Eidar.

Olafur Eliasson —— The concept springs of the idea of a get-together—a meeting place. It's something I've been discussing with all the people here: how do you share ideas and become productive? And stemming from this, how do you create an environment that both produces something and evaluates its own meaning? Based on these precepts, I thought it might be interesting to do a project where people simply get together. Initially, the idea was for it to concretize around the notion of a parliament—a concept that contained two important reference points in my mind. In Iceland there is a place called Þingvellir,

where the Alþingi, or national parliament, was founded in 930 AD. For Icelanders, it's the model of a democratic get-together where rules are established in order to constitute a system. On this level, then, the project would index the local culture. But the idea of a "parliament of things" is something I've also engaged with through a text by Bruno Latour that he wrote while preparing for his exhibition *Making Things Public* at the ZKM in Karlsruhe, in which he describes the idea that all things are relative and to be debated and evaluated.[5] I like this, and it's something I've focused on in much of my work—the notion that we all perceive things differently even though we're engaging with identical physical objects or environments. For Latour, it's not a question of universal rules that would define things, but an emphasis on negotiation. Anyway, to create this platform I have to make some formal choices, and that's precisely what I'm doing here in Eidar. It's difficult, though, because I'm trying to identify some formal boundaries or ideas that would not only create a nice setting, but also a place where you and I, or whoever, could get together. So far, I've been thinking about baths—steam baths, perhaps—where people could both sit on their own and also share an experience. I've called it a "garden of situations," but it's only a working title at the moment.

Hans Ulrich Obrist —— **You're also participating in the show at ZKM in Karlsruhe, aren't you? I'd be curious to know what you plan on doing there.**

(5) Bruno Latour and Peter Weibel, eds., *Making Things Public: Atmospheres of Democracy* (Cambridge, Mass.: MIT Press, 2005); exhibition at ZKM, Center for Art and Media Karlsruhe, 20 Mar–3 Oct 2005.

Olafur Eliasson —— It's my understanding that Bruno's approach—or his interest, really—lies in how to reinvent the idea of democracy. He thinks that democracy has failed in relation to the citizens it governs. In saying this, I think it's the *rules* of this relationship that he's after. I still don't know which approach I'm going to take, but Bruno has suggested that I do something related to the deCODE genome project. It stems from the ongoing interest in mapping the entire Icelandic population—both as a hobby and as a rigorous study. As the genome project evolved, the business of mapping the Icelanders became increasingly serious and was eventually institutionalized in a company that now maintains a database encompassing the whole genetic history of the Icelandic population. This is the reference matrix for the genome project. Bruno suggested that I talk to one of the people working on the project to see if this massive map of the population might be relevant to the exhibition.

Hans Ulrich Obrist —— This leads us to the mapping project you're doing here in Iceland and with which you've been involved for several years now. Of course, you're not making maps of genes, but of the country's surface—an endeavor that may span decades before it's complete. As I understand, you've been exploring different zones and photographing quite a bit. Could you tell me about this?

Olafur Eliasson —— Yes, it's an ongoing photography project. Every year—or several times per year—I research a natural phenomenon: waterfalls, lighthouses, caves, glaciers, crevasses, ice crevasses, or ice caves. It can be very simple, and I try to document as many forms

as possible. *The aerial river series* [2000] is one such example. Here, I fly from the beach up to the end of the glacial river Markarfljot and then document it all over again by sailing down the same river in a boat. As you mentioned, this has been going on now for years, and I'm building an index of all these different phenomena, some of which are unique to Iceland, while others, like lava shelves, are basic geographical features. I pick the images for various reasons because, as you know, I do a lot of spatially-related installation work. And much of that work is experimental, like laboratory research related to negotiating a few basic ideas: what is a space, and how is it generated?

Hans Ulrich Obrist —— Can you tell me how Iceland works as a studio or laboratory for you? You used to have an apartment or a house here, but you gave it up in lieu of a mobile home, which is this amazing vehicle—you've often referred to it as a mobile studio. Perhaps you can tell me more about this portable laboratory and your working methods while on the move?

Olafur Eliasson —— When I stay in one place for too long, I feel trapped. So I quickly decided that I needed some sort of mobile house that would facilitate my movement around the island. In many ways, Iceland is a young country, and it's very dynamic—especially the countryside. Indeed, if there's one thing you can say about the landscape here, it's that it's on the move: it's not completely defined, but in transition between different geological stages. So the mobile home has become a way for me to negotiate my relationship with the island. In fact, it's become even more significant

lately because my other studio in Berlin is large and rather cumbersome by comparison. With upwards of ten people working there, it's a heavy structure, and the working process is naturally slower. This is why I thought it would be wonderful and productive to have a smaller and more flexible kind of studio. The result, as it's played out in Iceland, has been an intense physical attachment to the environment, to my surroundings. We should be careful in calling everything a "studio," though, because in some respects it's much simpler than that; it's just working your way through something as an idea. In this process you're also able to define possible outcomes or solutions.

Hans Ulrich Obrist —— Maybe we could expand on this idea of movement and talk about the significance of geography in your work. I'm curious about the idea of belonging to a geography but, at the same time, moving and being between geographies.

Olafur Eliasson —— I see what you mean. There are some qualities about nature here that I find really interesting—for instance that it doesn't have a very strong level of representation. It has this immediate presence, but you don't feel familiar with it if you're not from Iceland, because it's so unique. Of course, there's always a certain amount of recognition, as you can relate it to your previous experiences, but here it's marginal, and because of this we don't have many expectations of what to see. Consequently, to the extent that Iceland provides a rather shallow frame of reference, it's difficult to project too far into the future—or too far back into your memory. This is quite radical in relation to

the Western conception of time, by which I mean the European notion of perspective and spatial understanding. So what we get here is a situation in which our commonplace relationship with space is challenged due to this completely abstract landscape with no frame of reference or vanishing point. And this, by consequence, shifts our comprehension of time—from objective time towards a subjective comprehension. Because this perspective is now located within yourself, the traditional space/time engagement is inverted. Indeed, you don't only engage with your surroundings; your surroundings engage with you. You become the center of the action here—hence my desire to constantly move, to perpetually reorient myself.

Hans Ulrich Obrist —— That's really fascinating, because it also leads us to the question of participation. And, again, this great moment of participation in sixties art—urbanism, architecture, and so on—has since turned into a cliché. Of course, the big issue now is how to go beyond the cliché. You just mentioned this in relation to the Eidar project in terms of getting people engaged and sparking negotiation. Could you tell me more about this very complex issue of participation and engagement, and how it can get past the cliché?

Olafur Eliasson —— Yes, the idea of participation has resurfaced constantly throughout the course of art history, quickly becoming institutionalized many times over. By this I mean that the potential of participation has often been lost. But I think we now have another model. We haven't been set free from the historical model, but we are orienting ourselves within a model in which the very idea of participation or engagement is the project.

It's not participation in the sense of physically working together, but more in terms of its ethical potential: if I help you, I implicitly have some sort of relationship with you. To the extent that this is now occurring, it means that we need to consider our mutual responsibilities very carefully. And in this way, the spatial questions I mentioned previously resurface: how do I move or act, and how do I accept that you might move or act differently than I do? I realize I'm speaking in the abstract, but fundamentally the participation I'm referring to is about defining a different understanding of subjectivity—you know, the idea of the self, of identity. And this is why I refer to it as "so-called" nature because the idea of the infinite, non-mediated, and original nature presupposes a higher state of truth that, I feel, is dangerous and slightly totalitarian. So it's all interwoven. This idea of a parliament here in Eidar—of sitting down and discussing the rules of negotiation—is very important. Ultimately, it leads to the question: how can we become responsible? And how can we take our responsibility seriously enough?

Hans Ulrich Obrist — **So by responsible space you also mean tolerant space. Can you perhaps expand on the notion of tolerance?**

Olafur Eliasson — Absolutely, tolerance is very important. When I talk about engagement, I often think of it as a means of absorbing your surroundings. However, it's not as if I'm about to walk over to a group of people and change something. It's more subtle than that: tolerance is not a set of rules by which I govern my surroundings, but the persistent ability and desire to

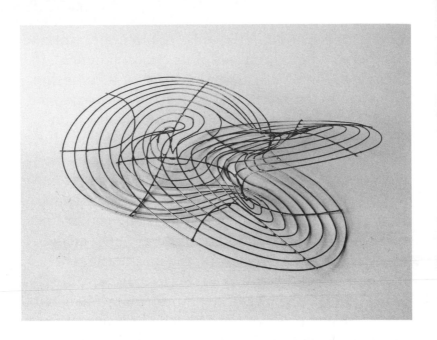

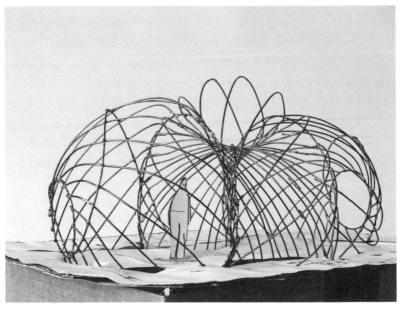

Models 1996–2003

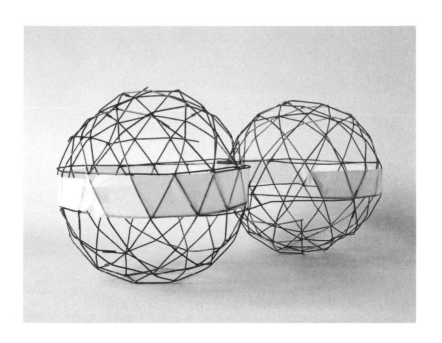

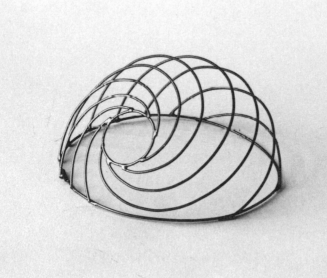

Models 1996–2003

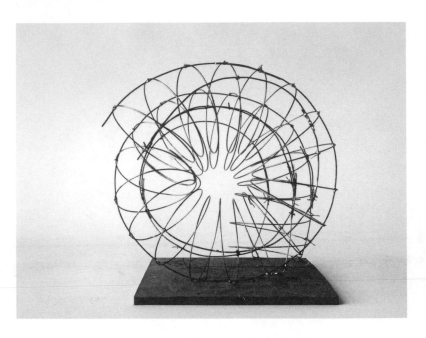

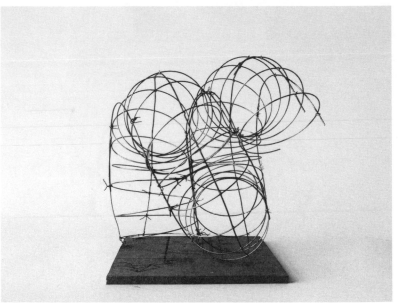

Models 1996–2003

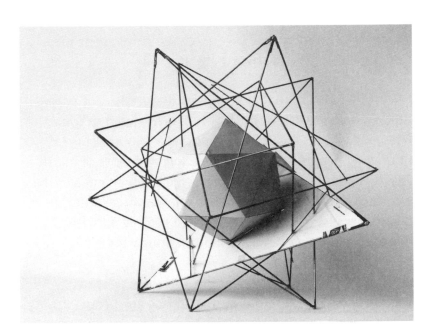

Models 1996–2003

share. It's the idea that the space we're in right now is not my space, but a shared situation.

Hans Ulrich Obrist —— And that also leads us to questions of urbanism. What you're describing is very much related to Yona Friedman and his idea of not imposing a master plan—of not telling people how they should live and move about in a city. It's about the urban planner being more an enabler than a controller. I was wondering how you see yourself in this regard, because you've also developed projects for cities. Is this a direction you want to follow in your work?

Olafur Eliasson —— To begin with, I should note that every space is charged, challenged, and has an intentionality. However, it seems that the modern idea of an urban collective or an open and so-called free space has disappeared. The generation of artists who thought they could set space free, so to speak, is dying out. I must admit, I'm rather uncertain about how to tackle this issue. Alternatively, I'm trying to focus on how urban space is constructed: where are the power structures? What layers of representation are actually at hand, and do they differ from those we think are there? Are we, physically and mentally, in a different location than we think we are? Are we being manipulated? Can we make urban space more transparent?

Hans Ulrich Obrist —— What about specific projects of yours in relation to the urban situation? One question I've wanted to ask you is tied to the project of an unbuilt city that you presented in the architectural design magazine *Domus* earlier this year. A more documentary idea is your project for UNESCO in Ethiopia, which is more about photographing cities.

72

Olafur Eliasson — Yes, through the idea of the unbuilt city, I've slowly realized how all of my work forms a sort of spatial language. I'm also developing this idea of how to construct and deconstruct at the same time: you can say something and both evaluate and critique it simultaneously, like in an endless loop. In this way, the city I envision might consist of all my works thrown together. I'm not sure whether this is another utopia and will fade, but it might just be how a city could work for me. Of course, it might only be suitable for myself—maybe I'll be all alone there or terribly unhappy. But that's another story.

Hans Ulrich Obrist — So the city would be an accumulation of all your structures—built and unbuilt.

Olafur Eliasson — Possibly. The one I was invited to do in Ethiopia by UNESCO was quite different, however. You know, in Ethiopia, there are these old Coptic churches—a whole city of churches that are inside the mountain or underground on this plateau in a town called Lalibela. The structures are more than 800 years old. I was fascinated by this idea of space carved out of a solid, so that first you have the block and then through the door and windows you carve out the inside until you have the space you like—just like a very complex cave. It also almost defines an understanding of yourself.

Hans Ulrich Obrist — This leads us to the question of your unrealized projects—the only question I always ask towards the end of my interviews. Please tell me about one or two other unrealized

73

projects of yours that you're particularly keen to see translated into reality.

Olafur Eliasson — Ah, every time you pose this question, I find it difficult to respond—there are just so many unrealized projects! The first thing that comes to mind, though, is that I would like to reinvent the idea of teaching. I want to explore different ways of conveying knowledge, especially outside of a formal academic context. I've been dealing with this for some time now, but have struggled to find an appropriate structure to bring it into being. So this is one of the projects I'd like to realize at some point down the road.

Hans Ulrich Obrist — Are you thinking of something like Black Mountain College—of forming a new school?

Olafur Eliasson — Exactly. That's one of the reasons I'm so interested in this place here in Eidar, because it could potentially be turned into a summer school—a summer camp or gathering that would be more elaborate than a series of weekend get-togethers. It could either exist for a couple of months or be converted into a much larger, heavier structure. But this is an unrealized project; or, rather, in Eidar it's just beginning.

Hans Ulrich Obrist — What about the do-it-yourself architecture you had originally proposed for Venice? You know, the genre of a do-it-yourself city. After all, it's related to various notions of participation and the production of space.

Olafur Eliasson — The do-it-yourself city derives from different ideas; one of these is the idea of sustainability—not

just ecologically speaking, but in terms of self-evalua-
tion or self-production. It's the idea, in effect, of hav-
ing a completely self-supportive and self-perpetuating
system. Based on this, I considered creating bricks or
tiles you could use to make a house. I've been working
on this for a while now and have become interested
in building-bricks and how they, to a large extent,
predetermine the shape of a space. These bricks and
tiles became industrialized in the late eighteenth
century—the very beginning, that is, of modernism.
Interestingly, this was also a time when psychology
changed its perspective on identity, spurring inquiry
into how identity and surroundings are interlinked.
I'm very interested in how identity and space are
negotiated, and I'm still trying to figure out how to
put the different components together: the sustain-
able idea of a person and his or her surroundings, and
utopia. Ultimately, I think this project will be realized,
especially if *Utopia Station* continues.

Hans Ulrich Obrist —— Hopefully it will very soon. My last question
is about the inadequacy of some of today's museums that
become less and less experimental.

Olafur Eliasson —— Yes, it's a good question to conclude with
because it somehow justifies this soft material we've
begun mapping here. Currently, artists are obsessed
with dematerializing, recontextualizing, or reevaluating
the object. I'm referring to the whole disappear-
ance of the object and everything now being based
on relations—the quasi-object. That's not a problem
in itself, but unfortunately museums are moving in
the wrong direction. Their approach to it remains

highly conservative: they're trying to institutionalize the object—and not just the object's physical qualities, but the *experience* of it. In fact, museums tend to commodify, or at least objectify, the experience of the object. And as this is played out, they narrow down the way the public sees things. To be frank, I think they've become producers of "seeing-machines"; they not only produce the art, but they dictate the way art is to be seen thanks to their event-driven and conservative perspectives on the object. So they're losing the socializing potential of art, which means that many contemporary artists are floating away from the museum. So the question is: who is going to be able to house the body of work being made today? Can it go into the museums? I don't know. The museums' conservative policies may be the death of this classic institution. If they're not careful, we'll end up with some weird sort of conservative archives, but no art houses.

Hans Ulrich Obrist — **Despite this, do you have a favorite museum?**

Olafur Eliasson — I'm fascinated by the Boijmans van Beuningen in Rotterdam, where I'm presently working on a show [*Notion motion*, 2005].

Hans Ulrich Obrist — **The Boijmans has an interesting spatial condition, because it has very big and small spaces simultaneously.**

Olafur Eliasson — That's true, and I find it heartening that they've maintained such a domestic feeling in this era of the global museum. It still has a personal aura, as if you were at somebody's house. I think it has a kind of social correspondence to the great works in Holland.

But I come from Scandinavia, so I'm familiar with this notion of architecture. Ultimately, I think we need to understand that there are many different kinds of museums, but they all have to allow people to look through them, to see the underlying institutional structure, and to understand that this is not a house of truth, but a constructed way of presenting history and reality to people.

Hans Ulrich Obrist —— **Thank you very much for this interview.**

IV — A post-medium artist
Copenhagen, December 23, 2005 [6]

Hans Ulrich Obrist —— Your studio in Berlin is like a big office, with more than thirty employees. What is your studio in Copenhagen like? What happens where?

Olafur Eliasson —— I've just started spending more time here in Copenhagen, although my primary studio is in Berlin. What I have in Copenhagen is more like a private studio; I have my library, and I can be completely by myself. I have only one employee here, so I can devote myself to my drawings and to reading.

Hans Ulrich Obrist —— Your recent work blurs the lines between art and architecture in terms of the tools you use and your participation in architecture competitions, such as the one

(6) First published in *Numéro* Magazine, Paris.

79

in Iceland you won together with Henning Larsen this year [The Icelandic National Concert and Conference Centre, Reykjavik, Iceland, due for completion 2009]. Over the past few months, there has been a quantum leap in your Berlin studio, because it's turned into something so much bigger than a traditional art studio. It's more like a factory of ideas. Please tell me about the changes happening there. Is it more an artist's studio or an architect's studio? Or would you say that these distinctions don't matter anymore?

Olafur Eliasson — The studio is really about art, and it just so happens that my art is relevant to the field of architecture. It doesn't do art justice to call it architecture—it takes something away from it. The point is that I have an ongoing interest in spatial questions. I've come to the conclusion that I won't be working as an architect, contrary to what I had anticipated two years ago. I still think what I'm fundamentally interested in is artistic practices that can take on the form, or the language, of architecture. What drives me is the possibility of implementing the unique qualities and potential of art in the spatial field of architecture. I see my studio more as an organic structure where people come and go. There is, of course, a core group there all the time, but there are also a lot of people who are more loosely connected to the studio, depending on the kind of projects we're working on.

Hans Ulrich Obrist — The news of your winning a major architectural commission in Iceland, alongside major architects, is amazing. Could you tell me more about this project and how you feel about creating a large building in Reykjavik?

Models 1996 – 2003

Models 1996–2003

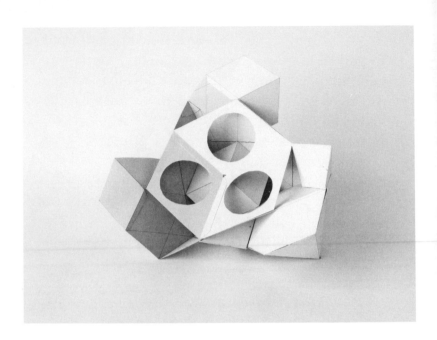

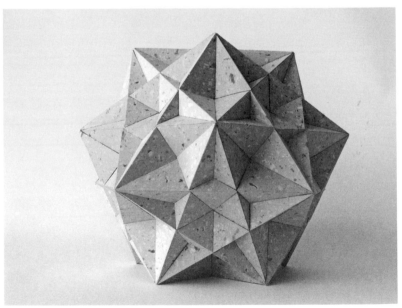

Models 1996–2003

Olafur Eliasson — What we have is a private company wanting to build a large-scale concert hall and multi-purpose conference center with auditoriums and smaller concert spaces. They've been collaborating with the Icelandic government and the Iceland Symphony Orchestra, but it remains a private venture. They've asked the Danish architect Henning Larsen and an engineering company from England to do everything related to the interior; I'm doing the exterior—the skin.

Hans Ulrich Obrist — **Do you already have an idea of how the skin will function?**

Olafur Eliasson — I've developed an idea based on a geometric shape derived from a form I've used several times before: it's a crystalline façade element, rather basalt-like. Every glass element is 2.00 x 1.45 x 1.25 meters; some of them are tinted, and some are reflective or semi-reflective. It's a very lively façade whose elements react very differently to light—to the internal light of the building and the external light from the street, as well as the natural surroundings. The very dramatic seasonal changes of light in Iceland make it appear colorful and kaleidoscopic.

Hans Ulrich Obrist — **Do you have any other architectural projects on that scale?**

Olafur Eliasson — Nothing on that scale, but I have made another project for a museum building based on the way the sun sets in certain towns. In every city the sun has a different angle to the horizon. In the Mediterranean region, for example, the sun sits

almost perpendicular to the horizon. The farther north you go, the narrower the angle to the horizon becomes. We could take the geometry of these angles, depending on the location you're in, and create a dome or a shell-like structure that is nothing but a solar dial. You could use this shell as a very big building; it looks like a dome, but if you stand at the center of it, every line, which could be made of beams, would be parallel to the orbit of the sun going up and down. This means that a museum building in Iceland would look completely different from the same museum in Sicily.

Hans Ulrich Obrist — Let's move from museums to the shopping environment and talk about the dark elevator you created for the new Louis Vuitton store in Paris [*Your loss of senses*, 2005]. The idea of artists creating art for shops can be a trap and even confuse or weaken their art. I was extremely impressed by your radical statement in this environment: you created a dark space in an otherwise illuminated shopping environment. How did you handle the difficulties inherent in this context?

Olafur Eliasson — It's about a certain type of subversion or self-reflective, introspective quality. It's also about a form that can be beautiful, but that's able to negotiate its own beauty. We're not necessarily dealing with deconstruction here, but rather constant renegotiation. Of course, a shopping environment doesn't emphasize this idea of renegotiation; on the contrary, the optimization of profit in such an environment emphasizes the non-negotiable, the universal truth, the hierarchy of what is good and, in this case, luxurious,

and what is less good or fashionable. We mustn't be naïve, of course—we all know that a shop would never intentionally do anything that is counterproductive to its core value, which is to sell things. My idea was to see whether it would still be possible to impose an artistic idea that both suggested its own language and renegotiated its position in that context. I told the people at Louis Vuitton that it was in their interest to have a real and serious work of art—that they wouldn't gain anything if they got an artistic statement that subordinated itself to the hierarchy of their shopping environment. They agreed, and the nature of our working relationship was absolutely professional and supportive, which comes as no surprise considering the scale of their business. They're highly professional.

Hans Ulrich Obrist —— **Are any of your other projects in a shopping environment?**

Olafur Eliasson —— Not at the moment. I did receive several invitations like this before the Louis Vuitton project and have also received several since then, but I've never come up with a good idea. The unique thing about the elevator is that I got a space for myself, which means that you're isolated. You're in the exact center of the building and yet you're completely lost.

Hans Ulrich Obrist —— **Weren't you also asked to design a new concept car for BMW?**

Olafur Eliasson —— They asked me to get involved with a specific model: a hydrogen car. The engine already existed, but pretty much everything else is design

ideas. Even though I'm neither a car designer nor a designer I've started researching the appearances of cars. This means that instead of making a car, I've asked why car-makers produce cars like that. I've started interviewing a wide range of people about cars, from Yona Friedman to the Dutch theoretician Bart Lootsma. I've asked them all what they think a car fundamentally is, and what role they feel cars play in our society. This is the current state of my research; later, I'll be taking a closer look at the materials. Of course, BMW is pouring millions into their research; they are so taken with materials that they don't care very much about the role of cars in society. I'm trying to address this and more fundamental questions, such as the political impact of cars.

Hans Ulrich Obrist —— Do you generally interview people as part of your research?

Olafur Eliasson —— The reason I do these interviews is to learn more myself; it's a way of saying to people that I'm not the mastermind of the project, at least not in the classic genius kind of way. There's no reason to pretend that I'm doing this all by myself; I'm going to involve various people in the project.

Hans Ulrich Obrist —— If you think about the manifesto of the Artist Placement Group in the sixties—where artists worked inside companies as infiltrators—this sounds rather like your position within BMW. Are you actually part of the company now?

Olafur Eliasson —— Not exactly. There are some fundamental differences between how they work and how I work.

I look more closely into the psychology and politics of experience when thinking about tangible objects like cars. This means that the phenomenology of the body and mind is at the core of my research about the car, whereas BMW has a much more pragmatic approach.

Hans Ulrich Obrist — **I was wondering what you consider your medium to be.**

Olafur Eliasson — I'm in contact with a company in China; we're talking about setting up a studio there to explore these kinds of questions. The point is, I never change my studio practices or the layout of my studio to fulfill a concept of how things should be. It's the other way around: it's the projects I've done that shape the structure of my studio. I'm not going to open a studio in this company just to have a branch in China. I'm waiting for an important reason before I actually do it. I don't think too much about the nature of my studio, because that's secondary to the content I'm working on. My studio can take on any shape.

Hans Ulrich Obrist — **So the studio can also be mobile? Can you work when you travel?**

Olafur Eliasson — Unfortunately, yes—I've been forced to. There's nowhere I don't work anymore.

Hans Ulrich Obrist — **As my final question, I'd like to ask which of your projects today—on December 23, 2005—is dearest to you.**

Olafur Eliasson — Right now I'm trying to make an instrument. It's not working yet, but it will at some point. When you play specific tones, a three-dimensional space is created through the vibrations of the chord. The idea is to measure the frequencies of the vibrations. A chord has a main note, a C for example, then it has a third, E, and a fifth, G, joining in to form the C major. You could give these tones spatial dimensions. This means that if you played a whole group of chords, you would suddenly have created a building out of various spaces, born out of the three-dimensionality of sounds. If you played a concert, a whole village could grow out of these sounds. It's a complex work. I can imagine a situation where you have a piece of music as an extension to a building. This could be scaled up endlessly to become an instrument. I can even imagine a loop where a chord becomes an instrument, which would make sound that would then be turned into another instrument, and so on ad infinitum. This is a hypothesis, of course, but I think it must be possible because music is dimensional.

V — The goose lake trail
Journey from Reykjavik to Eidar, Iceland, 2006 [7]

Part 1

Hans Ulrich Obrist — **Can you tell me where we are here? I'm lost.**

Olafur Eliasson — We are on the reverse side of Iceland.
South behind us, north in front. The wind, as you can
hear, is blowing from north-northeast. We are not
only on the rear stretch of Iceland, we are also behind
the rest of the group. The ten other travelers are
about four hours in front of us in two jeeps, keeping
each other company. Having lost them, we are now on
our own. We were delayed because we had to put our
map reader, Alain Robbe-Grillet, on a small rescue
plane. I think they are flying somewhere beyond us,

(7) First published in: *The Goose Lake Trail (southern route). Gæsavatnaleið (syðri). A conversation between Olafur Eliasson and Hans Ulrich Obrist* (Cologne: Verlag der Buchhandlung Walther König, 2006).

over the glacier. The air there is more dense because it is cooler, and the airplane can smoothly fly lower, so it is currently surfing the surface of the glacier down to Eiðar. This is also where we are heading.

Hans Ulrich Obrist — **When you take pictures on a journey like this, is there a system or is it random?**

Olafur Eliasson — I don't really tend, or intend, to take pictures in this type of landscape because it is so enormous. A photograph can never really capture this feeling. Normally I try to look for a little setting, or a little stage … a more compact environment that your body can engage with physically. Of course, the physicality of a landscape like this cannot be depicted in a single photograph; the vast dimensions are best experienced by traveling through it. So, with regard to the endlessness surrounding us, the time it takes to travel through the landscape becomes our way of measuring its physicality; the duration of our journey becomes our eyes. In an hour or so we will arrive at the glacier, where the landscape will be on a smaller scale, and I'll take some more photos there. Here I just thought it was an appropriate place to take a picture of you—your white hat and that piece of sky over there, the cloud shaped like the hat. You know what I mean?

Hans Ulrich Obrist — **It's a backdrop.**

Olafur Eliasson — A backdrop, yes. Look at the glacier over there, it's very sunny.

Hans Ulrich Obrist — **This is one of the biggest glaciers?**

Olafur Eliasson — Apparently it is the biggest glacier in Europe. It is shrinking rapidly, though, as are the rest of Europe's glaciers. But it remains the largest.

Hans Ulrich Obrist — What is it called?

Olafur Eliasson — Vatnajökull.

Hans Ulrich Obrist — And it erupts sometimes ...

Olafur Eliasson — Yes.

Hans Ulrich Obrist — The catalogue says it might erupt today.

Olafur Eliasson — An eruption might happen today, so we have to get beyond the lava tracks before they close the road. We can always try to drive over them. Let's go ...

Part 2

Hans Ulrich Obrist — Olafur, before we get out it would be good if you explained your survival car, because it has been transformed into a modified ready-made. You have added a hemisphere on top which makes it into some kind of Utopian laboratory. But it's not merely a survival kit, a tool with which to cope with the landscape, it's also your mobile studio.

Olafur Eliasson — It's a little laboratory-on-wheels and it mutates like a chameleon into different shapes and spirits. Initially, everything about the car was easily understandable and ready to be decoded. It completely corresponded, I'd say, to conventional expectations of

what a car should look like ... until the cupola entered the equation. The cupola was just to give it that dimension that it absolutely did not possess, namely the unexpected; it's the car's unpredictable reality. So the cupola, even though it is of course a minor element in the realm of the unpredictable (nor very large, either), closes what was once open and adds a kind of panorama aspect to the car. Now I can stand up in the back and have a look around; I can shower in the rain without getting wet; I can sleep here in the back and still have my little view of the sky. The car accommodates whatever kind of trip you want to have: we can bring a small kitchen if we want to have a chef-and-cuisine sort of trip, or we can just stock the usual astronaut food, which we did on this journey—much to our disadvantage, perhaps. We can really change it into anything. If we go fast enough it will start to fly—levitate, I call it. And it even sails if needed; hopefully this will not be the case. We also had a nice sound system put in recently. Maybe we should throw this song on. I think it suits the car.

Hans Ulrich Obrist — **We should listen to that later, it's great. A Sigur Rós piece ['Bíum Bíum Bambaló']** [*The editor suggests that readers listen to this song while reading the remainder of the conversation*].

Olafur Eliasson — Yes, exactly.

Hans Ulrich Obrist — **... with elements of traditional singing.**

Olafur Eliasson — Here we actually just arrived in what is called Gæsavötn. It means "The Goose Lakes." There is a nearby emergency-shelter that is surprisingly

well designed; it resembles a piece of Swiss or Dutch architecture. There might be a warden inside because it looks organized. We are still on the back of Vatnajökull, surrounded by small lakes. I don't think there are a lot of fish here, but geese abound. It is a national park, or kind of protected area, and up in front of us these black mountains comprise the soil that the glacier leaves as it recedes. So underneath all this black soil there is ice. You can actually see the glacier right there in front of us … we'll get closer to the ice as we continue driving.

Hans Ulrich Obrist —— Another thing you were telling me before is how you were once driving when a sandstorm struck, and you saw a group of people caught in the midst that you thought were stationary but were in fact moving on bicycles. So you were in a different time frame within the same space. I've just done an interview with Albert Hofmann, the inventor of LSD, and he recounted an experience in an experiment he performed during his first trip: while cycling home from his lab, he insisted that he believed he was standing still. Of course his assistant, who accompanied him because he didn't feel well, said that he drove like crazy. Is there a parallel, do you think, between this sandstorm experience and Hofmann's LSD trip?

Olafur Eliasson —— Well, the storm definitely does something to our senses insofar as our impressions of scale and proportion—our perception of reality in terms of "will we survive if we do this or that?"—are compromised. I wouldn't say that's necessarily dangerous, though. We might even be able to use such an experience as a tool, perhaps, to help later renegotiate or expose

the constructions of the usual dimensionalities that surround us. So even though we call this a land-scape, we could equally dub it a geometry. As there are no straight lines in this landscape except for the hut and flagpole, we are, so to speak, in a kind of non-Euclidean universe. Who knows if time curves more out here than it does elsewhere? I think the time it takes to travel across this terrain, our one-minute interview journey behind the Vatnajökull glacier, is actually about bending time ... it's about bending space; let's call it an anti-Euclidean journey. Ultimately, we don't know what we are seeing until we get home and rethink it all. The story you are refer-ring to occurred when I was here a couple of years ago with Marianne, my wife. We drove through a one-meter high sandstorm and spotted what we thought were these crazy people standing in the thick of dust really far away. As we approached, we could suddenly make out something shiny under their hands. They were in fact on bicycles, sailing in the sandstorm, so to speak ... levitating through this desert that we are going to encounter in a little while.

Hans Ulrich Obrist — **It's also interesting that yesterday I wasn't prepared, so the whole thing felt like a horror trip, whereas today it's a great pleasure.**

Olafur Eliasson — Sure, but I guess all trips involve the notion of preparation. Because I've been here so many times, I tend to think that driving through this lava field as we just did is like meeting old friends. Or rather, it's a mixture of both: I am actually seeing new things

98

every time, and old friends as well. But now I've lost it. What did you say about LSD again?

Hans Ulrich Obrist —— The preparation for the expedition. You've elsewhere called it "a telepathic expedition". It's a lot to do with a mental preparatory set.

Olafur Eliasson —— "Telepathic" is really just an acronym for a laboratory expedition project: T-E-L-E-P-A-T-H-I-C is The Eiðar Lab Expedition Project And The Highlands Interdisciplinary Communication. That is what telepathic means: it is about sharing this sense of negotiation, being able to bend our surroundings by negotiating them. So, in a way we have this interesting situation where we are put in a certain frame of mind or a certain atmosphere by the landscape, and at the same time we negotiate this very same landscape simply by being in it and responding to the things we experience. That's it. Here we are.

Part 3

Hans Ulrich Obrist —— Olafur, I wonder if you could talk a little bit about the repetition of your journeys? This is not the first time you've been on this route, for instance. Yesterday our driver, who is Icelandic and has done this route hundreds of times, said what strikes him is that each time he sees something completely different; he experiences the landscape anew.

Olafur Eliasson —— Certainly. Actually, this route has two versions: the northern and the southern. I've done the northern before—this I've already mentioned. They

are very close to each other, but the southern is more dramatic.

Hans Ulrich Obrist —— **This one?**

Olafur Eliasson —— Yes, the one we are on. You are not supposed to do it without having other cars with you, though. The rest of the group happened to go in front and we have people in the area as well so in a certain way we are all together. But this is the first time I've been on this route as well. When you come close to a glacier, the temperature and quality of the air change precipitously. For example, in the mere fifteen minutes since the beginning of this interview, the wind has turned south, creating a very strange situation in which we have blue sky and sun overhead but less than a kilometer, maybe a half kilometer, in the distance, rainy clouds loom above the glacier. The wind therefore makes this little strip open for us. Not that I mind the rain, of course, but it's funny that since we started the interview we've entered another weather system, and here we are ready to sunbathe on the stones because it's getting so hot.

Part 4

Hans Ulrich Obrist —— The next question is about the micro and macro aspects of landscapes. I know that you maintain this ongoing project of attempting to photograph the entire topology of Iceland—a mapping project. And you referenced this in a way just before: we've stopped here because you are trying to find more niches in the landscape in a more confined micro situation, so to speak. So there's both micro and macro.

Olafur Eliasson — Sure. One aspect about my excitement with this project is that it constantly varies, it changes a lot. To cover and document the whole surface of Iceland is actually more about the impossibility of creating an objective map ... but equally about how cartography has fostered a third-person point of view on our inhabited space. At some point, for instance, maps began to be so precise that one could actually relate to them as a kind of time dimension, enabling us to say: "From here to Rome is a half year on horse-back." A map thus also became like a clock, a temporal calibration. So in my project the idea of mapping everything from the air, documenting minutiae, all the glaciers, all the waterfalls, the crevasses, the routes, curved roads and straight roads, all these mappings serve to destabilize our usual conception of time. When documenting things, you also apply a new dimension to them; I apply what we talked about before—the different ideas of space—and question the dimensionality of things. I think that large-scale photography, rooted in a discourse of "vastness," "grandiosity" and "endless-ness," has to a great extent colonized the photographic medium. In contrast to this, a fantastic setting like the one we arc presently looking at forms a typology of space which is completely relevant for the body, for immediate physical experience. One could actually live here if it weren't for the weather and so on. We could construct a veritable dwelling: a house here, the toilet over there, a bed there and so forth. So this is what I am documenting. It is not so much about the land-scape in the abstract, nor about mediated photography as such; it concerns the spatial situations that a non-Euclidean landscape like this offers us.

Hans Ulrich Obrist —— **A habitat.**

Olafur Eliasson —— This is a habitat, absolutely, and a lot of different things for other people as well. It's a habitat against the sun with a blue sky ... which is actually, maybe, problematic; the long shadow next to us is so voluminous on the black stones that a photo might not show it properly, because essentially an image is always flat. The image might thus make this space appear uninhabitable. But, on the other hand, considering it habitable could turn it into something more spatial ...

Hans Ulrich Obrist —— **Experiments can fail.**

Olafur Eliasson —— And succeed, and create new languages.

Part 5

Hans Ulrich Obrist —— **Olafur, you were saying that it also reminds you of a little theater.**

Olafur Eliasson —— Well, it seems that I'll have to do a theater setting soon, and this is all you need. Of course, this is so classical.

Hans Ulrich Obrist —— **It also reminds me of the origin of parliaments.**

Olafur Eliasson —— Yes. This is just the place where we could sit down and sort out things, right? Doesn't it look like a parliament to you? Maybe this photo should be called 'The parliament photo' and these could be all the parliamentary members sitting around, all these rocks.

Hans Ulrich Obrist —— **What did you end up doing for Bruno Latour's show, the Karlsruhe exhibition [2005]?** It's called *The parliament of things* [*Making Things Public: Atmospheres of Democracy*], and he **was interested in you doing something about the very first parliament which, as far as I know, was in Iceland.**

Olafur Eliasson —— We ended up exhibiting the photo documentation I did of Þingvellir, which is where the first parliament and one of the ideas of parliamentary democracy originated. What I did was photograph all the crevasses—no, they're called falls, earthquake cracks in the earth's surface. There are some really fantastic ones there. Þingvellir is the place where the parliament assembled, and it is also where the eastern and the western tectonic plates meet. These falls are the result of the two continents shifting. So in a way we have a cultural institution, the parliament, that responds to nature in that both are in constant movement. Each in their own way incorporates a fundamental negotiation or disagreement, yet they never manage to fully break apart. The notion of the parliamentary idea, democracy and the tectonic shift was, I think, what made Bruno and Peter Weibel choose to use that image, because the exhibition was also about parliament's disruption.

Part 6

Hans Ulrich Obrist —— **We are here actually in a very strange sculpture garden or cemetery. It's not clear to me what this is because there are hundreds of small monuments. Sometimes in the Swiss mountains we have one or two of them erected by**

workers, but here we have a huge installation of life and a complementary one of death. What is this?

Olafur Eliasson — I don't know. It might be something that began as a rumor: somebody starts doing something and then others mimic this, turning it into a convention ... it's supposed to be "good." So this is one option. I guess the other one is the Icelandic tradition for sites to have qualities or spiritual powers of some kind, mythological powers. You know, it's not so much about the gods, but the elves and the small trolls that live here. They apparently cast a kind of curse on this place, so as you pass here you'd better put a rock on one of these things. This is probably the most likely explanation. Cognizant of the curse, people started doing this and now we are here, much later, without any idea of what curse we are talking about, so we'd better put a stone here, just in case.

Hans Ulrich Obrist — It's warm.

Olafur Eliasson — Are you OK now?

Part 7

Hans Ulrich Obrist — Olafur, I wanted to ask you a question about color. Reading Alain Robbe-Grillet's thoughts on color or its function in his films like *L'Eden,* he makes a number of strategic associations: red represents travel, or blue and white are the villages. Cumulatively, this produces a certain serenity, the pure sky, the flag of Jeanne d'Arc, the hatred of green. Shifting from Robbe-Grillet's Tunisian colors to our present journey; there has been a strong change of color on

our expedition as well. First there was that lava landscape, followed by the black glacier with the white underneath. So I was wondering if you could talk a little bit about color? One peculiar thing about this interview is that because it's been relatively spontaneous, the flow of the conversation changes at every interval ... it's responsive to the landscape.

Olafur Eliasson — Yes, and without sounding too banal, the landscape is an improvisation itself. Our experience in terms of landscape and color is really crucial. I think we, and a few older generations, are the first to understand that one should be careful not to talk about color and landscape in universal terms. A sensory experience may be valid for you and me in the present, but the danger lies in imposing our excitement and the sensual engagement in our great journey on others as more or less essential qualities. I am passionate about discussing colors, and I don't think it's wrong to voice emotions if I've just had a moving personal experience, but the responsibility that I have, or my generation has, is to be able to talk about something amazing, a beautiful color for instance, without imposing these universal value systems onto our contemporaries—the way former generations did. So I am perhaps in a situation right now where I would like to keep the colors to myself.

[*break*]

Hans Ulrich Obrist — To continue where we left off, it's not only the landscape's changing colors, but the strange, disorienting, physical experience of walking on such different surfaces. Walking on the edges, walking where there is ice underneath,

walking on the lava ... and now, seemingly, we are on some cave bubbles.

Olafur Eliasson — Yes, what we are driving and walking on are probably the roof-tops of what in the south of Italy would be called "trullis." Anyway, the consistency of the lava field and this particular variety of lava, the right temperature and so on, is such that it will not erupt. As far as I understand, these bubbles that we see result from gas or sulfur explosions underneath the surface, so there are probably scores of subterranean caves around here; we are basically walking on a city of caves right now. The thickness—let us just walk over here—this is the thickness of the roof; you can see how it has broken off like this.

Hans Ulrich Obrist — Your previous link about the caves is fascinating. Walking on caves.

Olafur Eliasson — And the glacier up there.

Hans Ulrich Obrist — The glacier somewhat resembles a Gerhard Richter painting. Its deep black, lava-covered surface melds together almost as an abstract painting. Some of the white ice becomes visible as well.

Olafur Eliasson — Exactly.

Hans Ulrich Obrist — There is a link to painting ...

Olafur Eliasson — Ah yes, absolutely. The white stuff we see all over the place is lichen, which is the only thing growing in this area. It's not exactly a plant, it's a very

low form of mushroom, but that's not the right word. Below the mushroom, even, is the lichen. So here we find the lowest of the low, and yet it's so vibrant.

Hans Ulrich Obrist — **Those bubbles that we're walking on, they make an interesting link to the bubble on top of your car.**

Olafur Eliasson — [*laughs*] Well put! Yes, one bubble is as good as the other. Look at that big mountain at the back there. It is called Helgafell, a legendary mountain. As you can see, just a bit north of it, where we are now, the wind is blowing from the south … rather surprisingly, because when we left it was the complete opposite. Just two kilometers away we had the rain following us all the time, and now we're traveling in a time tunnel of sunshine.

Part 8

Hans Ulrich Obrist — **Let's return to color. I'm fascinated by these yellow sticks and the fact that you've asked Joni Sighvatsson to leave us food in yellow bags. We haven't found a bag yet, but each time I see a yellow-painted rock I think it is our meal. This all makes me think of an objective correlative, an object which has a correlation with an act, either by prefiguration or by premonition, or by effect of a trace or sequence (this means that it's not a symbol). In a weird way those yellow things could be our meal, so it's a kind of premonition, but they are also our path. Sometimes we lose the path, and then through the yellow sticks we find it again. Can you comment on that?**

Olafur Eliasson — Objective correlatives. Well, they are definitely sequential in the sense that we are looking for one and the moment we find it we immediately look for another one. It's somewhat like following the numbers on a clock: each stick becomes a visible, tangible marker of the time dimension. The interesting thing is, when you get lost, you look for the yellow sticks, you look for time. It's very funny how when you lose your sense of orientation, the space also gets lost and your notion of physicality is challenged; you are no longer guided by the physical frame, but you seek the time frame in order to regain your physicality. Isn't that an interesting phenomenon? So our yellow sticks are pointing out the sequential aspects of what we are looking at.

A similar phenomenon applies to the weather: we have the sun over here, which has now disappeared, and we have the rain behind us, sort of catching up. It can't really decide whether it's going to rain on us or not. The funny thing is that if it started to rain and we were to sit here as we're now doing, the water would rise rapidly and we might lose our sense of direction. So the weather also serves as an orientation aid for us. If fog or a thunderstorm comes, we might get completely lost and we would have to eat beef stroganoff from the rescue box. But look, as I'm talking, the sun is breaking through. Maybe we just drove too fast and it's now catching up?

Part 9

Olafur Eliasson —— It's wonderful here. I'm afraid I'll have to take a photo.

Hans Ulrich Obrist —— Take a photo, that's good ... then we'll make Part 9, maybe with the photo. The title of your Tate project was *The weather project.* The weather, it seems, is also a medium of yours. Can you elaborate on this? In a discussion I had with Rosalind Krauss and Molly Nesbit some years ago, Krauss said that we're living in a post-medium condition. So the medium of painting as an isolated practice is no longer relevant. Ed Ruscha's medium, for instance, could be the car. I was wondering if the weather is your medium, and if you could talk a little bit about this? On this journey the weather has been a major part of the experience, almost as important as the landscape.

Olafur Eliasson —— I noticed when we got here yesterday that we had an eastern wind; we spoke about it, actually. The eastern wind comes over what is called the Hofsjökull, the Hofs Glacier, and normally that means quite good weather the next day. As I woke up this morning, however, I was saddened to see it had turned in a northerly direction, which is usually a sign of dreary weather and I quietly anticipated a rainy day, without wanting to spread too much bad news. I think we have had a stroke of luck, though, in that we've traveled along the rain curtain; in the northern half of Iceland, on our left, it is definitely raining and in the southern half it probably is as well, although I can't say for certain.

So many questions arise when speaking about the weather. One issue is how you orient yourself as an individual in either an urban or a landscape environment like the one we're in now. It's exciting to see, for example, how quickly you begin to use the weather as a personal compass. The weather gives air substance; the rain gives the air, which is normally invisible, depth. So when you have a big rain cloud, the rain falling under it gives you a sense of the cloud's size. The weather, then, is a tool for measuring our surroundings, especially in expansive landscapes like this one. So this is one aspect that I find interesting. The other thing worth noting is how the weather functions as a social organizer. It brings people out of their private spaces; it works in a more metaphoric or abstract way as a kind of shared environment. Right now, we both have the wind in our face and in this way the weather somehow overlaps our bodies. It's a kind of shared physicality.

Hans Ulrich Obrist —— It is also open-source. Nobody owns the weather.

Olafur Eliasson —— That's true. The weather is one of the few really public domains—even though meteorologists' predictions have taken it to another dimension of specificity. But I think it also depends on what context you are in. Here, for example, we might say that the weather is in a constant dialogue with the landscape we've been driving through: if it rains, it becomes completely black and shiny; if it's super-dry or if there's a sandstorm, it changes color; and if the sun is radiant, the glacial melt is so intense that the rivers rise enormously. So the landscape and the weather

function as an ensemble and your body is reciprocally isolated. Driving here alone, I'd argue that we would probably become more sensitive or hyper-sensitive because we'd become a little bit nervous.

Hans Ulrich Obrist — **More than if we were in a bus with others.**

Olafur Eliasson — Certainly, if we had the comfort and safety of driving with more cars together. But here we are lost and alone and there is literally no-one except an old English couple we met in a car driving in the opposite direction late this morning in order to make it down to Nýidalur in six hours. In any case, all I'm saying is that there are things we notice about the weather here because we are alone; experiences become intensified. When, for instance, we travel together or in two or three small groups, the sensitivity or engagement with the weather is completely different from our interaction with it in another social setting.

Hans Ulrich Obrist — **There is a participatory dimension to the weather.**

Olafur Eliasson — Yes. It's remarkable how quiet it is.

Hans Ulrich Obrist — **The difficulty with interviews is that one cannot transcribe the silence.**

Olafur Eliasson — Yes, yes. It seems that we are in a hole here because it's quite windy and if we look around there is nothing but a blue bag and some yellow sticks—a wonderfully obscure trail. I have to admit, I think this is the most rugged driving I've ever done in my life …

it was unbelievably physically challenging. I'm happy
we made it so far.

Hans Ulrich Obrist —— We even hit a stone.

Olafur Eliasson —— We even hit a stone, yes. Maybe we should
go and have a look to see if the car noticed or not.

Hans Ulrich Obrist —— Let's have a look.

Part 10

Hans Ulrich Obrist —— So it's been a four-hour drive and we've only
just found the yellow bag that the main part of the "tele-
pathic" expedition, now a couple of hours in advance, has left
behind. It was placed so well that we were able to recognize its
shiny yellow skin a few hundred meters away. The notion of
travel, the journey, has always been very important for you.

Olafur Eliasson —— Yes.

Hans Ulrich Obrist —— The journey as a medium.

Olafur Eliasson —— Sure, but I am trying to see things in per-
spective and I guess the notion of the journey really
only makes sense when you have some fixed point in
your life as well. Spatial dimensionality, time and all
the things we've been discussing are only significant
for me if they're reconciled as part of an overall assem-
bly of lived environments. My Icelandic excursions,
for instance, must be set in relief against the majority
of the time I spend in cities, in urban environments.
Of course, the journey is something that I personally

find great satisfaction in doing; it's one way of relaxing. I don't know if today's extreme trip is necessarily relaxing, in a literal sense, but I hope we can reflect upon it as such at a later point. We've been shaken and knocked into another sphere by the wild road here. We are currently, as we speak, tripping. It's all one ongoing trip, anxiety and ecstatic ideas blending in an all-consuming concoction. Look how unbelievably scary that whole glacial landscape in front of us appears. Is that not the wildest thing?! It makes 'Lord of the Rings' look like a reality show.

Hans Ulrich Obrist — Not such a long time ago, the Alps were still very scary. Think about Haller's *Alpen*: until the eighteenth or nineteenth century, the Alps were still very frightening, overbearing. But now, somehow, they've become beautiful. It's interesting, that pathway or transition from something being scary to beautiful.

Olafur Eliasson — Of course, and it's an area that has been touched by many people and not always in the best of ways. But the thing about the Alps and their location in the center of Europe is that they've almost become another theme park. The mountains have been industrialized or colonized into something no longer about spatial questions, but about mediated relationships. It is about media. They remain experiential, you can still experience the Alps, but you carry an image, a predetermined knowledge of what you are doing there. Here—and I am not saying this is better or higher-ranking—you have less of an expectancy register, so when you see something like the drama in front of us, it is slightly unsettling. There are no images or

reports to compare this to inside your head, nothing to calibrate it against. The fact that Iceland hasn't been mediated to the same extent as, say, continental Europe makes it special. Of course, everything is fundamentally mediated insofar as we carry and project ideas from one knowledge set onto others, but that's a discussion for another time. Even so, we've been going through a really remarkable transformation today.

Part II

Hans Ulrich Obrist —— Another thing that has struck me on this journey is the notion of the street. A few minutes ago, off the microphone, you said, "this is not the street." This seems to relate to the idea of a "song line," to Bruce Chatwin's description of the Aborigines—the ability to follow a kind of invisible line. It seems that you're guided by a certain local Icelandic knowledge, by intuition. On the one hand, the road obviously possesses an objective route (the yellow signs), but it also seems to disintegrate at times into a kind of field ... a spatial floor. All this is fascinating.

Olafur Eliasson —— It is. Another interesting thing is that the farther we travel, the looser our spatial quantifications become. We are not as stressed as we normally would have been; our notion of time changes, it becomes less rigid. But getting back to this idea of the line, the road, intuition: the yellow sticks begin to blend in and they almost become a surface. Our current trajectory is very different from the one we started out with—it has now become a special mode, or an emotional state of mind. We've suddenly covered twenty-five miles

on sand in half an hour whereas we spent two hours crossing five miles of rugged stones earlier today.

Hans Ulrich Obrist — **We have entered another zone of streets. It's no longer the red desert street, but a floating sand-dune street where the car drive becomes like a boat ride.**

Olafur Eliasson — Yes, we have been sailing, we have been sliding back and forth and I have been putting my effort into staying on the road and not straying into the desert on another journey. Now we are driving in black sand, or black ash, actually. It's a fun ride. It's so funny how your speed relates to the landscape you are driving in. One kind of landscape generates one kind of speed or emotion and another may vary drastically in both respects.

Part 12

Hans Ulrich Obrist — **Perhaps it's now time for the only recurrent question in all my interviews, which concerns your unrealized projects. This could be about your unrealized Icelandic project, or something else perhaps?**

Olafur Eliasson — I have a feeling that underneath Iceland there is another country. There are so many caves and there is so much space that we just don't see here. The road we have taken today might even exist in a parallel framework below us.

Hans Ulrich Obrist — **You mean a parallel reality? Something like in David Deutsch's *The Fabric of Reality*?** [8]

(8) David Deutsch, *The Fabric of Reality. The Science of Parallel Universes and its Implications* (New York: Allen Lane, 1997).

Olafur Eliasson — Yes and no. The project I'm contemplating has to do with the volcanic activity here, these bubbles we're walking on. I was thinking of trying to turn one of the large cave systems into a kind of social housing project. It's about time that we moved back into the caves. Let's try to turn the great caves on the southeastern part of Iceland into a city. Can you envision that, a cave city? So I was planning at some point to both put on an exhibition down in the caves and to exhibit the caves themselves. I think it would be a fascinating context because the usual ideologies and values that you find embodied in museums would be absent in a cave like that. You can't really predict what would take place down there—some system or structure, of course, but the communication of the art would be different.

Hans Ulrich Obrist — This is fantastic.

Part 13

Hans Ulrich Obrist — Maybe it would be good to continue this section of the interview with an exploration of your relationship to architecture and urbanism, of reorienting your work to larger and larger building schemes. You've just framed your unrealized project around this idea of an underground city, and you've developed a prototype of an urban plan for an entire city for the Italian magazine *Domus*. I understand you also have plans to eventually build a museum in Russia, so I thought we could catch up on these architectural questions.

Olafur Eliasson — Well, it's really not that far stretched to envisage artists generally, and myself especially, taking

spatial questions that we constantly deal with and applying them to architectural propositions. I think artists are in a unique position to participate in, and contribute to, spatial situations in a progressive manner—potentially in different ways than formally trained architects. For this reason, it makes sense to start working with a system that communicates and integrates art into society. I've increasingly begun to think, for example, about the actual construction or reconstruction of museums instead of merely producing installations. This relates to the idea of art being inseparable from its institutional supports, how or where it is shown, so it really does make sense to look at architecture as part of my overall artistic practice. What was the first part of the question?

Hans Ulrich Obrist —— **Maybe you could tell me a little bit more about this concrete project for *Domus*.**

Olafur Eliasson —— The *Domus* project was about how one could consider my works as an ensemble, a topography that one could actually walk through—at least as a fantasy. What I'm driving at is that while creating installations, spatial-based artworks or situations, I've begun to envisage a city forming. All the works together, slowly they form a little map or a little urban plan. By placing the works in relation to each other, I could generate a sort of urban situation where one sequence might pass into another, generating not just one experience but an interconnected series of experiences, of mutually enhancing utilities. It would be a kind of engagement with built-in challenges, varying levels of resistance, just like a city offers you.

Part 14

Hans Ulrich Obrist —— We talked about your photographic mapping project in Iceland this morning, your encyclopedic drive to map the whole country, the creation of an imperfect atlas. But you've pursued some other projects in Iceland as well, for example in the context of the Biennale.

Olafur Eliasson —— This was actually a rather small project, an adjunct to a larger show. I erected a pavilion structure, a kind of viewing platform on a small island outside Reykjavik. I suppose the point was that you could take a little boat journey from the city to this island and from its highest spot, where I constructed this viewing post, you could look back at Reykjavik or further upon the landscape itself.

Hans Ulrich Obrist —— The river is another medium which has played an important role in your practice. One of your first pieces to deal with this was at the Berlin Biennale, when we worked together and you actually colored a river [*Green river*, 1998]. You've done likewise in Moss, Stockholm, Tokyo and Los Angeles ...

Olafur Eliasson —— Yes.

Hans Ulrich Obrist —— I'm interested in this because the river has also played a substantial role in our trip today. We've been crossing rivers and you've explained to me how to read a river—where it's deep, shallow and so forth. Let's talk about rivers.

Olafur Eliasson —— There are obviously people who are much better at this than me, but, in my own humble way,

one aspect that has long fascinated me is how a river stands as a threshold or boundary that one has to cross, as we've done several times on our journey. Luckily, it has not been very wet, but at the end of the day we encountered some rain and saw how the water level rose. When this happens you can study the river's surface and formulate judgments about what lies beneath: its depth, the rock density, things like this. These might seem like academic concerns, but they're exceptionally important when you have to cross it, especially if you are passing through a very long or wide stretch.

I'm not sure if you noticed, but I was just studying these factors a minute ago, trying to determine whether we should go left or right … if we would be able to cross with dry feet. Through a little analytic estimate we could identify that the area with the small, spiky waves was where the rocks appeared to be, whereas the section with the soft, slower-running waves seemed to be deeper. Of course the river we just crossed was fairly shallow so it turned out that we discussed these factors more for excitement and knowledge than for any practical benefit.

Hans Ulrich Obrist —— **What about the river in your work? In relation to your mapping project we spoke before about the impossibility of making a synthetic image of the whole country. This seems similar to your intimations that one can never really measure a river, that its length is impossible to quantify precisely. There will, as you stress, always be order and disorder.**

Olafur Eliasson —— That is true and the river, as we said before, is completely dependent on the weather, the season and the time of day; in the morning there is little water, then there is more because of the sun and at night it becomes very shallow and so forth. The river, nevertheless, has another element to it, namely the question of whether—how shall I say this … ? Some interesting questions about temporality are raised when you see the water of a river passing by. I have to do this in the edit because Merleau-Ponty has a lovely story about the river somewhere … in his *Phenomenology*,[9] I think. [Merleau-Ponty tries to show the degree to which our conception of time is related to our understanding of the body in space. In order to illustrate his point, Merleau-Ponty asks us to imagine that we are standing half-way down a hillside by a stream whose source is located at the top of the hill. In this situation, we would think that the water passing by us was previously higher up the hillside and will subsequently run all the way to the bottom of the hill. But no, Merleau-Ponty writes, the water exists all the time, whereas it is only in relation to our body that past and present come into existence. If we float down the stream in a boat we will experience the water as a continuous "now," whereas the landscape suddenly will appear in the past due to the new location of our bodies. It is only as bodies in space that we are capable of grasping time]. Very often we tend to talk about the notion of "now" or of "time" as a little cut between past and future, but the river somehow is a "now" including the past and the future in a very graceful way.

(9) Maurice Merleau-Ponty, *Phénoménologie de la perception* (Paris: Gallimard, 1945). Engl.: *Phenomenology of Perception* (New York: Humanities Press, 1962).

Hans Ulrich Obrist —— Besides *Green river,* have there been other occasions when your work has dealt with rivers?

Olafur Eliasson —— Well, I have done a lot of photo documentation of rivers. For example, this river called Jökulsá á Brú is going to disappear in one and a half or two years, so last winter I documented it from a plane. Coincidentally, the sign over there through the window says it's only thirty kilometers from here to the big dam which is being built at Kárahnjúkar—the dam that will destroy this river. These photographs, anyhow, are a form of documentation, a process of cartographic mapping. It is interesting that in a couple of years when people look at this river, it will no longer be about "now," but about "time." There will be a memory transferal: how the river is versus how it was. The piece was shown in Iceland recently and we printed it as a newspaper, based upon the last Eidar project.

Hans Ulrich Obrist —— This reminds me of Bernd and Hilla Becher's photographs of obsolete industrial architecture.

Olafur Eliasson —— Exactly. And the Jökulsá á Brú archive changes just like that; the piece has a particular meaning in one context, and a different one as time carries on.

Hans Ulrich Obrist —— How do you deal with the impossibility of documenting an entire river? Is it executed in sequences? From the air? On foot?

Olafur Eliasson —— This particular piece was recorded from the air, but I have done walking documentations of rivers in some older works. I also documented the

Green river project here in Iceland, and in another instance I rafted through a huge canyon on the south coast of Iceland and later flew above the same river and captured it from a bird's eye perspective. It is called *The aerial river series.* This was a very physical experience and involved launching a little rubber boat into the river. I was hanging off the edge shooting photographs while a few others were paddling, setting our course. It resulted in a completely different view of the river than from the air … it was highly dependent on our surroundings, the spontaneous manner in which the boat just jumped and danced downstream. So the river's physicality is hugely important to me, and the time it takes to sail is obviously very exciting and important as well.

Part 15

Hans Ulrich Obrist —— Thank you. And we hit the road again. We have passed an enormous number of bridges today. Let's talk about bridges. Have you ever built a bridge?

Olafur Eliasson —— In my Bregenz exhibition I had a bridge.

Hans Ulrich Obrist —— Bridge the gap, mind the bridge, mind the gap …

VI — It's the journey, not the destination
Flight from Eidar to Reykjavik, Iceland, 2006

Hans Ulrich Obrist —— This is the first time we've done an interview on a plane; we're on our way back from Eidar, and it's essentially the same route we previously traveled by car—we're probably going to fly over the very same highlands. We've just left Eidar, where the rest of the group is participating in a symposium. One of the speakers is an environmentalist. How does this relate to Iceland, in particular?

Olafur Eliasson —— A large proportion of the cities in Iceland are located on the coast, and some of them are only one meter above sea level. The speaker is going to discuss what is likely to happen in the wake of global warming. Apparently, the sea level is going to change so dramatically that the country's coastline will be

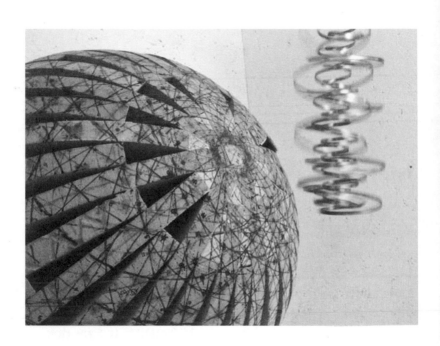

Model room, 2003, installation view at Lunds Konsthall, Sweden, 2005

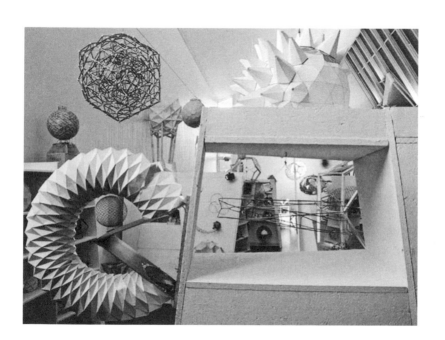

Model room, 2003, installation view at Lunds Konsthall, Sweden, 2005

Model room, 2003, installation view at Lunds Konsthall, Sweden, 2005

completely different and a lot of the cities will be submerged unless they develop a huge system of dams.

Hans Ulrich Obrist — **Will Reykjavik be affected?**

Olafur Eliasson — It seems that roughly half of Reykjavik will disappear, and many scientists predict that people from southern Europe will begin moving north as it becomes intolerably hot and dry in the south. In Italy it's probably going to be a lot like it is in the Sahara today, Berlin is going to resemble Morocco, and all the French wine companies are going to move to Denmark and Sweden. This also means that a lot of people will be migrating to Iceland—so we may need to found a new city on the highlands, far above the sea.

Hans Ulrich Obrist — **So one purpose of the Eidar meeting is to discuss the planning for this new city?**

Olafur Eliasson — I think a group of people is already working on this, actually.

Hans Ulrich Obrist — **Will the city be built in the highlands where we went last year?**

Olafur Eliasson — I don't know the exact location, but there will have to be a source of geothermal heat, since one of the ideas is to create a large roof system, much like the one Buckminster Fuller envisaged for Manhattan.

Hans Ulrich Obrist — **We're now returning from our fourth meeting in Eidar. It's become a regular meeting, it's difficult to imagine a summer without it. How do you see the future of Eidar?**

Olafur Eliasson — There are a number of directions it could take. If we're not careful, it could become a very traditional, predictable conference. Another possibility is that it will continue to consist primarily of group talks, similar to those we had yesterday. I think we should try to ensure that the gathering remains less structured, with just a few people meeting here and there, occasional film screenings, and so on. We need to de-institutionalize it to counterbalance the fact that it has already become quite set as a structure.

Hans Ulrich Obrist — So you think the best approach would be to emphasize these interstitial situations?

Olafur Eliasson — There's a certain type of language—a certain type of discussion—that doesn't work with thirty people sitting around a table. Although having everybody focus on the same thing can create a kind of momentum, I still think we should be careful not to systematize our time in Eidar too much. It might be a good idea to have it last for a whole week, with two or three focus days, but several leisure days as well.

Hans Ulrich Obrist — This reminds of a discussion we had a couple of years ago when you told me you were returning to Copenhagen to found an institute—a kind of art school that might become a new Black Mountain College. What's the status of this project now?

Olafur Eliasson — I thought I would be able to establish a creative environment in Copenhagen, but actually I underestimated the provinciality of the city. I don't want to sound arrogant, but the people I mentioned

the idea to were unable to see any potential in it. I still think it's a good idea, however, and I'm working now on realizing it in Berlin. Copenhagen will remain a personal retreat for me—a place that provides me with inspiration.

Hans Ulrich Obrist —— **How will the school work?**

Olafur Eliasson —— The idea is to establish an interdisciplinary school that focuses on spatial issues. It will do so primarily from the perspective of art and artists, but it should also have a group of architects and perhaps several scientists working on, for instance, psycho-physical issues. The school should offer some sort of post-graduate degree; I think it would be nice to have a group of PhD candidates affiliated with it—people who would continually draw upon the school's ongoing work in their research and writing. In other words, the school is not about producing artists in the traditional sense, but about introducing a vocabulary through which artworks can become much more integrated into society, social structures, and scientific and architectural discourses. There's great potential in the younger generations of artists. The problem is just that the established educational systems are still pushing the production of art into rather conservative directions.

Hans Ulrich Obrist —— **Would it be fair to say, along the lines of Doreen Massey, that space will bring all of these things together?**

Olafur Eliasson — Yes, I think she is a key person when it comes to thinking about space. And it's not going to be a big school; it will have only around twenty or thirty students taking part in a one-and-a-half or two-year program. Some of the educational components we need to establish through our laboratory, through our experiments, so it's very hard to say exactly what the school should be like, aside from being about establishing itself as a process. We're not attempting to create a new doctrine. One could assert that Black Mountain College became rather programmatic in its approach. However, its scale, intimacy, sincerity, and a special kind of engagement nevertheless led to many sophisticated conversations. I think that's exciting. I might reconsider my stance towards Copenhagen in the future, but for the time being the environment in the city doesn't seem to favor this kind of experimentation.

Hans Ulrich Obrist — In contrast to Berlin! Recently, while I was recording a conversation with Thomas [Demand] and visiting your studio, I was amazed to see the huge range of projects you were working on: you had started to explore the project for BMW and were doing various architectural pieces, the museum project for Washington [at The Hirshhorn Museum and Sculpture Garden], and even some work in the realm of fashion design. The last time we spoke, you said you didn't want to reject any of these commissions, but were seeking to function almost like an architectural office. Can you tell me more about how your studio works at present?

Olafur Eliasson — Well, I've managed to destabilize the formal aspect of my work a little bit. Or, to put it more simply, I suddenly realized that I could engage,

without too much difficulty, in various other exciting fields. Because it was never really about form, but about approach and content and language. Coming to this realization meant that I could address a much wider range of projects. As you know, my approach to things very much involves experimentation, and this is where the studio became crucial. Sometimes it has a life of its own, and sometimes I am very involved personally.

Hans Ulrich Obrist — **I'm curious about the specifics, though. When I was in your studio, I saw some works made of black tiles you've been developing for an architecture project; I saw your architecture maquettes, your fashion designs. Could you tell me more about how these different projects are evolving right now? The project that struck me the most was the one for Washington. It's particularly interesting in terms of what museums need to be doing to remain relevant in the twenty-first century.**

Olafur Eliasson — We're seeing a discussion emerging about the future of museums. Five years ago, I think the question was "What are museums about today?" But now people are asking, "What role are museums going to play in the future?" Of course, the museums themselves are afraid that they're going to lose their status as an important part of art production. They're very interested in finding ways to justify their own practice as museums: how can they create an infra-structure that makes it highly interesting for artists to use the museum as a way of communicating? I've spoken with the Hirshhorn Museum and Sculpture Garden in Washington about this. As we've recently

seen, some museological systems are actually counter-productive when it comes to presenting certain types of art. I think museums are not just vehicles for experiencing art, but also for introducing discussions about art, time, subjectivity, and identity. Perhaps museums should not be so obsessed with claiming that they're the only place one can experience art, because by doing so they isolate themselves.

Hans Ulrich Obrist —— **How do you avoid this dilemma in your project for Washington?**

Olafur Eliasson —— One of the main issues is that museums have considered themselves to be neutral, passive containers in which works of art were displayed. But the idea now, of course, is that museums need to build a different infrastructure and see themselves as performative players, as having a mediating impact on the artworks. There's also the question of how museums can work with the idea of sequential experience, part of which are the gaps on the wall between the paintings—perhaps they aren't as important as the paintings themselves, but important nonetheless. How can you convey to people that what they're seeing is a flow rather than a series of dots? I don't think the entire architecture of museums has to change; what has to change is the attitude of the museum.

Hans Ulrich Obrist —— **How will this work with your façade?**

Olafur Eliasson —— I'm not entirely sure yet, but fundamentally it's about being non-normative—about generating an understanding of experience that isn't based on

generalization. Of course, there's still a feeling of community or collectivity—some sense of experiencing something together with other people—but the foundation of experience must be in the individual. If museums tell you what to experience, they start to patronize you and generalize the experience by assuming that it's the same as that of the next person. This is counterproductive to the artistic potential. The way to address this issue architecturally is to emphasize the individual experience—to create an architectural program or form that suggests that dialogue and negotiation are crucial. If people feel they can negotiate the shape of the building, changing the light or the angle they view it from, the architecture will suddenly be based more on correspondence and dialogue than a unifying kind of understanding.

Hans Ulrich Obrist —— **The negotiations with the museum in Washington are related to your negotiations with BMW, which, I understand, have become quite complex. In our last interview, recorded around a year ago, you had just started on this project. The whole idea was to make it a research-and-development car—a driving force. How is the BMW experiment progressing?**

Olafur Eliasson —— The people at BMW are very professional and open and I went to their design studio, which is highly sophisticated. But to a certain extent they also have pre-conceived notions of what constitutes art, and what doesn't, and they're naturally very focused on creating a car that's a commercial success. So, I've had to look elsewhere for inspiration; I needed to find

or create a different kind of design language. So I made my first design experiment using ice.

Hans Ulrich Obrist — **You had an ice car in the studio and discussed it.**

Olafur Eliasson — Yes. First we made the experiment and then I showed the car; it wasn't about cars as such. I felt this was important in order to avoid it becoming too formal. But the point is, I'm just trying to find the right words, the right language.

Hans Ulrich Obrist — **The BMW experiment sounds less like a product design, and more like a process. It reminds me of your beautiful experiment at the planetarium [*The afterimage experiment*, Zeiss Planetarium, Berlin, 2006]. It was one of the most amazing things I had seen in a long time. I'd love to know more about how this experiment worked.**

Olafur Eliasson — It was an extension of what I do in my studio. I wonder whether it was really a successful experiment, but it's occasionally nice to get an audience to evaluate a project together with you. When you sit next to somebody who is looking at the same thing you are, you can suddenly see things through their eyes, simply by virtue of their presence. That's why I think it's interesting to make experiments like the ones we did at the Planetarium. This one was the first of a series of experiments with color perception and afterimages. I'm very keen on working on a film based on these experiments.

Hans Ulrich Obrist —— Is this related to the Birmingham show? [*Your uncertainty of colour matching experiment,* collaboration with Boris Oicherman, 2006]

Olafur Eliasson —— The show at the Ikon Gallery was much more about uncertainty in color matching—that is, whether you and I actually see the same color when we look at an apple or any other object. The fact is, we don't see them as the same color. It's close enough that we can agree on calling it "blue." But to be precise, it's "bluish"—we don't always see the same color, even though we take this for granted. There's a certain visual sensitivity that language doesn't account for, and I feel it's important not to underestimate this sensitivity. Maybe our color sensitivity has more potential than we think.

Hans Ulrich Obrist —— There's an advertisement here from Hertz on the back of the seat: "It's the journey, not the destination." I think that's a nice motto for this interview. We've talked about your studio and your public experiments, so what about your travels? Do you work on planes? What do you think about viewing the airplane as a studio?

Olafur Eliasson —— Airplanes are very odd spaces, because our sense of gravity, direction, and dimensionality is completely challenged. Without even realizing it, we have a different sensitivity to time and space. We have a different imagination.

Hans Ulrich Obrist —— Do you work when you travel?

Olafur Eliasson — Yes, a bit. I normally do my e-mails and those kinds of things. But I've also succeeded in curtailing my traveling habits, reducing my carbon footprint, so to speak. But, in any case, the issue is about time, space, and collectivity. I think this is something we should keep in mind, because people spend so much time on planes, and our surroundings are very different when we're flying.

Hans Ulrich Obrist — As my last question, I'd like to ask you about books, because you have our new book in your luggage: *The Goose Lake Trail*.[10] Books play an important role in your work. You've just done an amazing artist book with Lars Müller [*Your Engagement Has Consequences*[11]]. I wanted to ask you about books as a medium.

Olafur Eliasson — I should have mentioned this when we were talking about the studio: I'm starting a small publishing project.

Hans Ulrich Obrist — A publishing house?

Olafur Eliasson — Yes—well, it might turn into a publishing house, but it looks as though I'll be publishing between five and ten books over the next two years. For instance, all my studies, my work on the BMW car, are going to become a book. At the moment, I'm even discussing the potential of making a magazine about life in the studio: it would be something of a window to the studio and would emphasize the importance of the journey rather than the destination—the importance

(10) Olafur Eliasson and Hans Ulrich Obrist, *The Goose Lake Trail (Southern Route)* (Cologne: König, 2006).
(11) Olafur Eliasson and Daniel Birnbaum, eds., *Your Engagement Has Consequences: On the Relativity of Your Reality* (Baden: Lars Müller Publishers, 2006).

of the methodology and the language and the way I work, rather than just looking at the final products or results. I'm also considering working more with the internet, because I have so many people asking me for all kinds of things, and perhaps the internet could generate a different kind of dialogue.

Hans Ulrich Obrist — **And what about *Your Engagement Has Consequences?***

Olafur Eliasson — It's built around three different shows and contains a lot of material on what things look like before they actually turn into something, so there are a lot of unfinished works in the book. [*Looking out the window:*] It really looks like Russia or East Germany.

Hans Ulrich Obrist — **Why?**

Olafur Eliasson — Because a lot of the buildings from the sixties here are standard building units imported from Moscow. They were cheap housing projects, especially in the suburbs. You see them all over the place in East Germany, too. Look at those down there.

Hans Ulrich Obrist — **Dieter Roth mapped all houses of Reykjavik. What is your relationship to Dieter Roth? I don't think we've ever spoken about him.**

Olafur Eliasson — I'm a huge fan of Dieter Roth, especially of his books, which I have a lot of. His love of life has inspired me, as have his unstoppable ideas, which were very challenging.

Hans Ulrich Obrist — **Will you also publish other people's books?**

Olafur Eliasson — It's something I would certainly like to do. Hans, we're landing now.

Hans Ulrich Obrist — **How long has the flight been? Only fifty-three minutes—.**

Olafur Eliasson — Welcome to Reykjavik!

VII — The vessel interview, part I
Flight from Berlin to Dubrovnik, 2007 [12]

Hans Ulrich Obrist — This is the second interview we've done on a plane, but this time the flight is the payment for a project you did for NetJets Europe. Could you tell us more about it? I'm particularly curious because I curated one of my first shows on Austrian Airlines when we invited, together with museum in progress, Alighiero Boetti to do *Cieli ad alta quota* and Andreas Slominski to do *A Flying Carpet* [1994], and it seems that you've designed a flying blanket [*Skyblue versus landscape green*, 2005].

Olafur Eliasson — [*laughs*] Yes, we're in the air right now enjoying NetJets' last payment to me for the little project I did for them. I don't think there's much to be said about it except that it was a blanket—it wasn't

(12) On the way to Francesca von Habsburg, Lopud Conference and opening of Olafur Eliasson's and David Ajaye's *Your black horizon* Art Pavilion, Lopud island, Croatia, June 20 – October 31, 2007.

exactly a carpet, but a little blanket that you could wrap around yourself if you were cold.

Hans Ulrich Obrist — **On the flight?**

Olafur Eliasson — Yes, but I wonder whether it was actually used on the flight. In any case, to make a long story short, I received an invitation to do a little blanket, and as I've been fascinated by ideas related to arts and crafts, I accepted the commission. Since the support provided to me to do this blanket was more than ample, I was able to design a rather sophisticated blanket, weaving it in many different colors. Part of the payment was the flight we're on now.

Hans Ulrich Obrist — **But it's also interesting because it's related to how your studio works. If you recall, you showed me all these different things, such as a fashion line—things from all different kinds of fields, products related to the world of architecture, etc. So, like an architectural or design office, you took on a variety of commissions and started to negotiate with them. And I think this NetJets project is probably part of that section of your studio.**

Olafur Eliasson — Actually, I don't think I'm changing my practice in that sense. The important thing for me is that we remain free to choose the format we want to work in artistically. I feel it's important to be able to take on the challenge of testing artistic ideas in different formats. This is why I've become increasingly interested in investigating whether I can do projects that live out in the real world, which is essentially my view on how artistic ideas should work. I'm also

144

interested in how a project can work as a piece of clothing—as a raincoat or an umbrella, or as a blanket or an object. So I don't really see it as a change; it's just developed naturally like this.

And as to the rather large projects, there was one for Louis Vuitton [*Eye see you*, 2006] and one for BMW [*Your mobile expectations: BMW H2R project*, 2007]. The interesting thing is that working on those two projects, I entered a circle of people who are normally not working closely with the art world. What I discovered is that they have a completely different language. So although it was an artistic and critical project, it was also a challenge in terms of communication. There's a certain problem of elitism in the art world, in that the language that's spoken simply doesn't have a very broad scope. So I'm interested in reaching out to these other worlds—not just to the world of global economy, but to people who might be interested in an object's meaning.

This all being said, it's important to keep in mind that the BMW and Louis Vuitton projects, together, represented less than five percent of the work going on in my studio—even though roughly seventy-five percent of the exposure I received during that period was related to them. So they were, in fact, small projects in terms of the time it took me to make them, but they were huge in terms of the exposure.

Hans Ulrich Obrist —— **The Louis Vuitton project was really a planetary issue in a way because it was displayed in many different cities. They suddenly popped up in all of these windows—**

almost on the same day, I think. It was really like a pop-up—a global pop-up show. So in this sense, it was more like a generic sculpture that could work anywhere. And yet you're also defining another type of circulation in terms of money and the economy, because it helped your foundation. This is interesting because it also entails the idea of artists entering into philanthropy. Jeff Koons initiated a philanthropic foundation for children. Could you tell me more about the sculpture and the economic aspect of the project?

Olafur Eliasson — Yes, the project focused very much on the relationship between what's inside and outside the shop window. It's about the particular intentionalities the two spaces have—the way the luxury goods store projects a value out onto the street and how most people in the street only have access to that value through the glass. My challenge was to make a device or lamp or projector that would illustrate the fact that there's a boundary involved and that the street is the more interesting of the two sides. So I proposed the idea of illuminating the street, or projecting light onto the street, as if it were a stage in a theater.

Hans Ulrich Obrist — Did you do more research on light?

Olafur Eliasson — Yes, it was similar to a lamp you'd see at the dentist's, where, if you look into it very closely, you see your own reflection. That played a part in the project. Also, I successfully negotiated with Louis Vuitton that there would be no commercial goods in the windows. Considering the fact that the project was during the Christmas season, you can imagine that this was rather radical. But my idea involved a very clear statement.

Models, 2001, installation view at Zentrum für Kunst und Medientechnologie, Karlsruhe, Germany, 2001

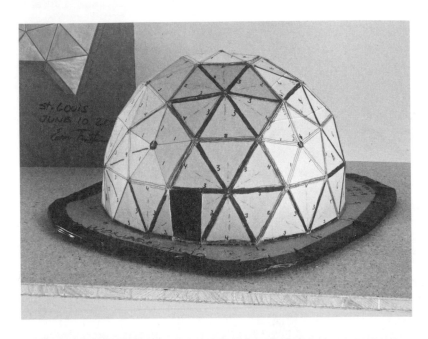

Models, 2001, installation view at Zentrum für Kunst und Medientechnologie, Karlsruhe, Germany, 2001

I wanted it to be an empty window; it was more about the idea of a window than a functioning window. And Louis Vuitton accepted that.

And, finally, yes, it made sense for me to do the project because of a different matter as well—that is, to collect money for philanthropic purposes, pursued by me together with my wife and friends. This is related to the fact that the Louis Vuitton brand is one of the biggest luxury brands in the world; at about the same time, we became involved with an Ethiopian orphanage, which is state run and was probably one of the worst orphanages in the country. This provided me with the opportunity to connect something very, very low—very, very poor and mismanaged—with something very, very high. I was able to give a handshake in Ethiopia and then shake hands with a top, high-end representative of Louis Vuitton all on the same day. This is quite important in terms of raising questions of responsibility today.

Hans Ulrich Obrist — Could you tell me more about the foundation? What is its mission, exactly?

Olafur Eliasson — For now, we're working on it as we go along. The main purpose of the foundation is to promote the idea that the way we live should produce some kind of responsible reality. Every week, my wife and I, and the people we involve in this work, contribute two to five percent of what we earn to the foundation. It's almost like a little tax we've placed on ourselves. We are no longer members of the church; in Denmark, the so-called church tax is about one and

a half percent of your income. In Germany it's eight percent, I think. So essentially we tried to find a way for a small percentage of everything we do to go to our foundation. The core issue is to try to find a form of micro-organization through which we can create a positive outcome—such as in the example I mentioned with Africa—simply by living. It's not about stopping what we're doing and then moving on to something different. It's simply about saying that even if we live today in a very luxurious and unbelievably fortunate situation, we have the opportunity to create economic sustainability. It's highly personal, because the foundation doesn't use our name or try to convince other people to take the same approach we're taking. Of course, I wouldn't be opposed to the latter, but when a collector buys a work of mine, the gallery doesn't tell him or her that a small portion of the money is going to a very good cause.

Hans Ulrich Obrist —— **So it's implicit philanthropy?**

Olafur Eliasson —— You could say that. But there are moments when I quite explicitly reach out. Take, for example, the orphanage we're working with right now. Some of the teenage girls were raped, so suddenly there was an urgent need to install walls around the buildings. There are 250 girls on the compound, and there was no way to monitor the whole place and protect it from the outside. So I called up a very generous American couple—dear friends of mine—and told them about the problem. They donated 75,000 dollars to build this almost one-kilometer-long brick wall because the existing corrugated wall basically was falling apart.

So that's an example of where our foundation's small budget can't cope and how I reach out to others for assistance. What we can promise in return is that we personally make sure that the wall is built, and the donators then receive documentation of their contribution. It's a one-to-one organization—a micro-organization. We have a homepage; you can find all the information you need there [www.121Ethiopia.org].

I think one of the biggest problems with this kind of work in Africa is that people tend not to know how to help—besides maybe sending money to Oxfam, which is also fair enough. But the point is to find a way of living that actually makes a difference. Of course, this could quickly become slightly patronizing or moralizing, and I don't want it to be that way. It's just a way of living with something that's dear to you, and, obviously, having adopted two children from Africa you get another overlapping destiny, which is a vehicle for us to do this, as well.

Hans Ulrich Obrist —— That's one production of reality. But what about the BMW project, which, I would say, is on a larger scale than the one for Louis Vuitton? There's this initial idea of BMW inviting artists to paint or decorate a car. It also involves a kind of engineering problem that requires pooling all kinds of knowledge and research. Could we talk a little bit about this project, and also about where it stands and how it's evolving?

Olafur Eliasson —— It's a fascinating project overall, and it's been interesting to engage with something as common as a car. One thing that's been challenging, but seems

to be working out, is the fact that BMW's motivation is promotion. And because I'm interested in raising critical questions and doing research that is not based on promotion, we've had few minor clashes in terms of the project's integrity. But I see this as a challenge, and I'm quite serious about my idea that art should take upon itself the responsibility of negotiating the way we produce reality together. I think it would be wrong to turn our backs on the corporate world and say, "I don't want to talk to you because you're only interested in promotion." After all, our lives are organized around marketing, capitalism, and the flow of goods. So the challenge for me has been to see whether I can succeed in these negotiations. In the context of working with BMW, I have been able to communicate a critical statement.

I should add that there are a lot of good things being initiated within big companies like BMW, such as research on sustainability. The quality of the research they're doing is high, as is the sophistication of the engines they're working on. So this means that, altogether, the complexity of the situation has been rather edifying. Also, they were able to agree to my idea—to tolerate my idea—of not wanting to become a promotional element within their company. This has made the project productive for both parties. The car is now being shown for the first time in San Francisco [Museum of Modern Art], and from there it will go on to Munich and then, I think, to Japan. I'm curious to see what comes of it.

Hans Ulrich Obrist — I think our readers might like to know how the car works.

Olafur Eliasson — There are two main interests for me. First of all, the car has a hydrogen engine—it drives on liquid hydrogen. Its combustion produces only water. So the project is related to ecology, the oil industry, fossil fuels, and global warming. That's my first main interest. The other is the car as a moving device. The fact that we move is, of course, closely linked to temporality and the way we experience our surroundings. And it's related to city and landscape planning, to spatial theory, and to our bodies. We tend to forget that we spend a large proportion of our lives in vehicles like planes, cars, and trains that transport our body at much greater speeds than we would be able to achieve on our own. But what does it mean to experience our surroundings through a glass plate that is perhaps a little bit like a shop window in terms of isolating the senses? If you combine the environmental issues with the way we move our bodies, then the project becomes extremely interesting. Suddenly we're confronted with a whole range of questions related to subjectivity and collectivity: why would you drive a car when you can take the bus? What is so liberating about being alone in the car? One of the insights that has come out of working on this project is how a design object can actually support or sustain ideas about being "singular-plural"—in other words, about being part of a system and yet sustaining some degree of individuality. If we just make a little loop: essentially, looking at luxury goods through storefront windows is also closely related to questioning our desires, fantasies, and the

idea of the self and consumerism. We could say that the car is a container.

Hans Ulrich Obrist — I'd like to ask you to tell me a bit more about this recurring concept of the singular-plural. It seems like a key concept for you. Can you explain how it works?

Olafur Eliasson — My last book was called *Your Engagement Has Consequences*, and the titles of my works indirectly speak about what singular-plural means and how the idea of the singular can be nurtured and handled in a responsible way. I've stressed that communicative effort related to art shouldn't be normative. Unfortunately, institutional systems today have a tendency to be normative or to generalize the experience of art to some degree. But how do you actually take your own individual experience of something and do something productive with it? How do you create a conception of individuality that, in today's society, has an impact? This is where the idea of plural or collectivity or "being-with" comes into play. Suddenly, it actually matters whether you are part of a context. And this feeling that you're part of something is extremely valuable for productivity or the production of reality. So when I talk about being singular-plural, it's about the feeling of "being-with." I would suggest that the singular only really works as a concept if there is some understanding of collectivity. To emphasize the complexity of this, it's probably important to mention that in Scandinavia, where I grew up, the model of the welfare society and the idea of collectivity were stretched much farther than in the rest of Europe. It was a very successful model in many ways, considering

that France, for instance, ended up having a very dogmatic version of it, and Germany is essentially—well, let's skip that whole thing with Germany.

Hans Ulrich Obrist — **Let's speak about Germany.**

Olafur Eliasson — I just don't know. I'd like to say something about it, but somehow Germany has such a different story with the East-West developments. It's hard to draw comparisons. But what I meant is that, eventually, the notion of collectivity in Scandinavia became so dogmatic that it ended up being inflexible—somehow it seemed to suggest or create a kind of intolerance. And this is to some extent anchored in the welfare model; it simply generated rules for how people could be happy, and then they started living by those rules. But times—and, with them, values—changed, and suddenly we were living by rules that no longer applied to the times we were part of. People started becoming more intolerant. That's what we have in Scandinavia today. But, as I said, looking at the rest of Europe, Scandinavia might actually come across as a pretty sustainable society considering the different types of phobias we find elsewhere. At any rate, there seems to be an increasing desire to re-evaluate the meaning of the words "collectivity" and "individuality" nowadays. I'm not talking about the new kind of right-wing desire to create a society based on a lot of egoistic ideas where everybody is responsible only for themselves—which I think is happening in Great Britain, for instance. We need to emphasize the importance of public coherency or the notion of the public or the state, as such, and within

that to find a resourceful model for being individuals. The terms "individual" and "collective" are often considered polar opposites, and what I think art and good design and architecture can succeed in doing is to place the idea of the singular *within* the idea of being plural. Suddenly, the word "feeling" becomes very crucial here. Within the plural, you can still feel capable of handling your own life—that your life has consequences and that you're an individual. This is where the term singular-plural comes from. I suppose we're still waiting for thinkers like Bruno Latour and Jean-Luc Nancy to add further dimensions to the meaning of these words, to help them have a sound impact on society. I think it's a question of a larger movement altogether.

Hans Ulrich Obrist —— I'd like to return now to the idea of the vessel: the Louis Vuitton project as a type of vessel, the car as another vessel, and the pavilion as yet another. Rem Koolhaas, who, together with Cecil Balmond, did the Serpentine Pavilion last year [2006], said that a pavilion without content is a meaning-less shape. So a vessel is always also a carrier of content. This brings us to your pavilion for the Serpentine [2007], which you co-designed with Kjetil Thorsen, invited by Julia Peyton-Jones and me [the Serpentine Pavilion project was initiated by Julia Peyton-Jones in 2000]. It will be one of your first larger architectural structures. Before we talk about the relationship between art and architecture in general, perhaps it would be a good idea to discuss the pavilion and the way this spiral-like space evolved.

Olafur Eliasson —— As you said, a form without content is meaningless; and, I would argue, a form without time

is not even a form. Or you could say that content is also time, because content can never be a picture; content is only content when it's real, and reality is only real when there's temporality. So we've tried to amplify the idea of content by giving the pavilion a shape that stretches temporality. "Stretching" here means that it almost translates your presence into a temporal matter. But I can answer your question more specifically: we have focused on a ramp and the movement around the center of the pavilion. It's almost like a centrifugal force. The dynamics involved in the pavilion's shape are closely related to how you experience it as you move through it. This, of course, suggests that the best way of seeing this pavilion is to involve yourself with it. And this is where the content is produced. Content is not just programmatic—it's also when people go from a state of indifference to a state of difference, it's creating difference. And if the shape of the pavilion can transport people from indifference to difference, whether they like it or not, we have already created something. This is why the sails, the floor, and the roof are a kind of animation. Every aspect of the design has been laid out to suggest that if you move, the pavilion will immediately look slightly different. And, of course, it's based on the quite simple idea that if you lift people off the ground, you challenge both their horizontal and vertical orientation.

Hans Ulrich Obrist —— I'd like to ask you to tell us more about what you'll be doing at the Manchester International Festival [June 28 – July 15, 2007], because you haven't spoken about that project yet and it's related to this discussion of temporality. The notion of temporality is clearly at the center of *Il Tempo*

157

Del Postino in Manchester, where Philippe [Parreno] and I are trying to curate an exhibition in which art is not about occupying space, but occupying time. To some extent, it's a question of time in relation to a group. I'd also be curious to know your thoughts about *Il Tempo Del Postino.*

Olafur Eliasson — I feel the idea of a narrative has suddenly become more apparent again. And the opera, obviously being about a narrative, seems to have a challenging dimension to it as an occupation of time. But if you take the narrative out of the opera, you're left with a durational sequence that you can fill up with projects or works of art. It's not unlike when you walk through a gallery and see an exhibition with many spaces, except that here they're walking through you, so to speak. You're sitting still and the space is performed in front of you—the museum is being built up before your very eyes and then taken down one space after the other, each with its own narrative and all linked to each other by a meta-narrative. It's interesting because the opera world seems to have reached its limits, being, as it is, so set within its own frame of reference. It has mutated into a conservative field that only in few instances reaches out into reality. At the moment, temporality might be the most constructive dimension if you want to create a narrative. So my idea is to challenge the very basic questions of what a space does—that is, the audience in relation to the stage, and vice versa. What does that offer? What is the most generous kind of set-up in a theater considering the history of the theater, the history of stage design, and the organization of sound within that visual frame of reference?

Hans Ulrich Obrist — **You made a soundtrack—could you tell me about it?**

Olafur Eliasson — I started by reversing the audience and the stage by installing a mirror that covered the entire stage. Then, I have suggested that the conductor turn around in the orchestra pit and try to conduct the audience, with the musicians following him. I am hoping to create an echo. The idea is that somebody in the audience may say something, cough, make a noise with the chair, or simply clap his or her hands. In turn, the conductor will ask the musicians to try echo the sound. So the musicians, like the mirror, basically reflect the audience—or rather the sound of the audience. Somebody may gasp or two people whisper to each other, both of which I imagine can be easily replicated by a couple of instruments under the guidance of the conductor looking at the audience. The musical "score" carries with it, of course, the danger of there not being any sound at all—if the audience decides to stay quiet—but no sound is obviously also a sound. It's a sound-no-sound soundtrack.

Hans Ulrich Obrist — **We've spoken about a variety of vessels in this interview. Before we close for today, I'd like to ask you about the idea of the museum or the art institution as a vessel. In the past, we've talked a lot about what art centers and art institutions need to be like to remain relevant in the twenty-first century. What is your vision of the twenty-first century art institution?**

Olafur Eliasson — I feel that cultural institutions need to embrace temporality in a more productive way.

By temporality I mean being a part of society, simply being a part of the world. I think what even quite isolated places like Black Mountain College succeeded in was actually creating a relationship with the time in which they took place. Black Mountain College became part of utopian governing—of the thinking of time. We're currently in a situation where the idea of museums, detaching the object from its context and its time, has caught up with a lot of institutional thinking. So one could raise the question of whether institutions, as such, are coming to an end—at least as we know them. The question is whether exhibitions, like the ones you're doing on a daily basis at the Serpentine Gallery, will hold their own in society. We may need to change things much more radically to embrace the times we live in or address the needs of the future—in terms of what art can deliver, what art can do. This is why I think that integrating an educational system—like an art school or art academy—into the institution is important. Essentially, an art school is producing the future, and a museum or an institution is producing the past. This is why I wonder why the Serpentine doesn't open up an academy, inside and outside the Serpentine. And why don't museums, American museums for instance, embrace the fact that one can be both representational and presentational at the same time?

Hans Ulrich Obrist —— **And what about books as vessels? I remember, at the very beginning, when we worked together in the nineties on various projects, you did these photocopied books for our exhibitions. You made fifty of them for Johannesburg, for your first Venice Biennale, and for other shows. And this has**

gained a wholly new dimension now with your extraordinary MoMA book, which is a real vessel, because it's a house as a book [*Your House*, 2006].

_{Olafur Eliasson} — Bruno Latour says everything is part of the parliament of all things. I think a lot has already been said about the book as a vessel—things that are probably much more meaningful than anything I could say. In any case, the good thing about a book is, of course, that it focuses primarily on writing, and everybody expects this intentionality to be the carrier of meaning. The book I gave you, however, has a conflict in it, because the only way to read it is to flip the pages that don't contain any text. It's a spatial proposition, consisting of a model of my house in Copenhagen and made out of 452 individually laser-cut pages. I wanted to explore the fact that reading a book is a physical and a mental activity—it's like walking through a house, which in itself creates a little narrative. In Western history, there's a conflict between narrative and space, the narrative being representational and the modern conception of space being one of authenticity or immanence. And that's why I like the book, because it somehow isn't immanent but you create a little spatial narrative by leafing through it.

_{Hans Ulrich Obrist} — Thank you, Olafur.

VIII — The vessel interview, part II
Flight from Dubrovnik to Berlin, 2007

Hans Ulrich Obrist — We're back on the plane, and this reminds me very much of a previous interview we did on our way back from Eidar. That's when you looked at the landscape and made the comment that the way back is always different—a repetition of difference.

Olafur Eliasson — When we flew back in Iceland, we talked about flying over the route we had previously traveled in the other direction by car. We flew pretty much exactly over that route. It's interesting because when you travel through a landscape, you measure a distance by referring to it as time. In other words, you say, "That mountain is one hour away." Or if you're hiking, you might say, "This is a four-day hike," which already gives you a sense of the distance because the

body can normally only do so and so much in four days. And then, when you start hiking, you begin to use smaller temporal elements, even if you've got a map: "That plateau is four hours away, and the valley is probably twenty minutes from here because it's downhill, and then the green area behind it down to the lake is another two hours." Yesterday on Lopud Island in Croatia we talked a lot about space-time relationships, institutional practices, and making a difference. But this difference—nobody actually spoke about what it is. We all vaguely suggested that it's related to the inclusion of temporality. So flying with you now, thinking about Iceland and this idea of distances in landscape being temporal, comes to mind.

Hans Ulrich Obrist —— It's repetition and difference not only in terms of our journey, but also in terms of the pavilion, because on Lopud Island we just saw the Venice Pavilion—the collaboration between you and David Adjaye [*Your black horizon*, Art Pavilion, Venice Biennale, 2005]—but in a very different light.

Olafur Eliasson —— That's true, and now the pavilion has a history. You could tell from the patina of the wood that it's grown old. In Lopud, it was already a familiar structure in the way the light came through the front side; it was all about memory and re-experiencing it, whereas in Venice, it was more about the expectations of what it would become. This time it had a different kind of gravity—the gravity of memory. It seemed somehow deeper and more solid on the ground—perhaps also because it's going to be there for a few years, whereas at the Biennale we knew it was transitional.

In Croatia it has a lot of different qualities. There's a community and cultural history that's less related to art tourism. Venice has become a museum. In Croatia, the pavilion seems to suggest a contemporary relationship between the island and the community—the time we live in rather than an agglomeration of museological ideas. The pavilion, I think, makes the island much more contemporary.

Hans Ulrich Obrist — One of the interesting things about this journey was that it was also a journey into the past. On the panel this morning you talked a great deal about your beginnings, and I was intrigued by your remarks about *Gestaltpsychologie* and the importance it played for you in art school. When was this exactly?

Olafur Eliasson — In the late eighties, early nineties. Phenomenology became extremely important again in the early nineties as it reintroduced, in a sophisticated and complex way, a relative understanding of object versus subject—that is, of objects in the context of time and space and what those relationships mean and perform. When I started art school, one thing that seemed interesting to me about *Gestaltpsychologie* was that it worked with a specific idea of the subject—the subject as a very productive entity. This was unlike phenomenology, which had a much more formal or objective idea of the subject. I think *Gestaltpsychologie* works specifically because it also has more to do with cognitive science and neurology. This is what triggered my interest—the idea that you could reinterpret the meaning of the individual based on the experience of the artwork.

Hans Ulrich Obrist —— And who, in those early days, were your teachers? Who were your heroes?

Olafur Eliasson —— When I read about *Gestaltpsychologie*, I focused on the general, basic experiments—about how expectations could influence the way you see very elementary ideas. Now I would probably say Maurice Merleau-Ponty and Edmund Husserl, and a little bit later Gilles Deleuze. But when I work in my studio, things are a bit less philosophical and more hands-on, and this idea of something more pragmatic or utilitarian is more closely related to *Gestaltpsychologie* than it is to phenomenology.

Hans Ulrich Obrist —— We've never really spoken about art school and who your teachers were.

Olafur Eliasson —— I forgot to say who my heroes were. I went twice to America to work, in 1990 and 1991, and this was when the art market crashed and everything changed completely. It was a very odd situation for me, arriving the day after the crash. It was almost entropy. I was working for an artist called Christian Eckhart. He made monochromes and was one of those neo-geo-artists, with a slightly more spiritual element to his work—icons and so forth. He gave me the book about Robert Irwin, *Seeing Is Forgetting the Name of the Thing One Sees*,[13] which was very inspiring. Then I started looking from Robert Irwin to James Turrell to Gordon Matta-Clark, Larry Bell, and Maria Nordman. So these were my heroes, but I think they lacked a kind of frictional relationship with the world.

(13) Lawrence Weschler, *Seeing Is Forgetting the Name of the Thing One Sees: A Life of Contemporary Artist Robert Irwin* (Berkeley, etc.: Univ. of California Press, 1982).

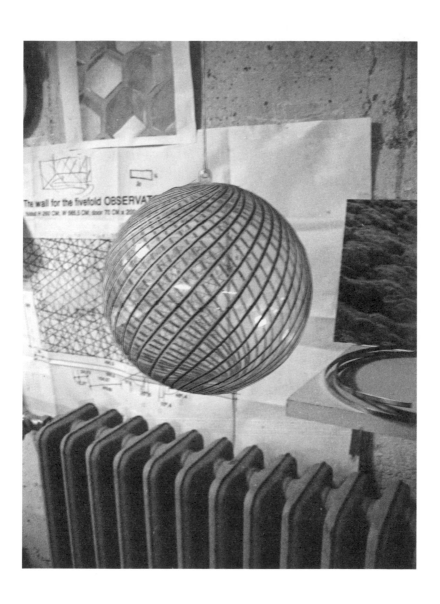

The wall for the fivefold OBSERVAT

Models 2004–2006

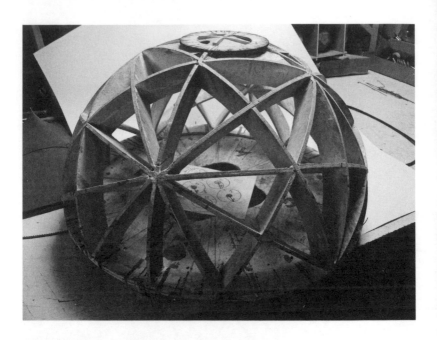

Models 2004–2006

In an odd way, they seemed to live on their own planet. For me, I think Robert Irwin was the best of the group. He's remained so true to his principles. But I've also become more interested in Michael Asher. There was an amazing show of his in Switzerland.

Hans Ulrich Obrist —— Do you mean the show in the Kunsthalle in Bern where he liberated the heating radiators [*Michael Asher, Kunsthalle Bern, 1992*]?

Olafur Eliasson —— Yes, that one. It was a very important show for me. Gordon Matta-Clark, Robert Smithson—basically where things became more about reality again.

Hans Ulrich Obrist —— And what was it about Robert Irwin that interested you?

Olafur Eliasson —— I liked the fact that, in contrast to many of the others, he wasn't into mysticism. His work is about pragmatic ideas about the body, space, and experiential issues. He's a very generous and spiritual person, but his work isn't about illusions—it's about reality.

Hans Ulrich Obrist —— I'm also curious when you began to feel that you were part of an artistic generation—or at least when you began to feel that there were other people around, who had similar time-related interests.

Olafur Eliasson —— The first time I realized I was part of a generation was when I discovered that the similarity was not in form but content. The nineties were really the time when form was liberated—everything was post-form and post-matter. And content could

to some extent prescribe the form, because the relationship between form and content changed. Form became polyphonic and performative; it became non-prescriptive, leaving much to the engagement of the individual. This is why I also said that phenomenology in the early nineties fell short of being productive, because it essentially maintained the already existing idea of what a body and a subject could do in terms of relationships with the surroundings. But as soon as content was considered a performative element of the work, I started to realize that I had a generation of people around me. Just think of the work of Carsten Höller, Philippe [Parreno], and Dominique Gonzalez-Foerster.

Hans Ulrich Obrist — **And Rirkrit Tiravanija?**

Olafur Eliasson — Rirkrit is so special, but it's also about friendships and the artists from the gallery in Berlin of which I was part—Michel Majerus and the painter Franz Ackermann, Tobias Rehberger, even Sharon Lockhart and some of the other L.A. artists.

Hans Ulrich Obrist — **Felix Gonzalez-Torres once told me that Andrea Rosen's gallery felt like home, and I've always had the feeling, in terms of your gallery, that there was a very close relationship. And then there's your shared studio space with Tacita [Dean] and Thomas [Demand].**

Olafur Eliasson — It's important to understand that a good gallery can help an artist make better art. It's as simple as that. And this has nothing to do with the market—with the commodification of objects or with

what a gallery fundamentally is, which is a dealer of art. Because a very good dealer doesn't just provide the artist with resistance or friction, but gives him a frame of reference that can be productive. I think the gallery in Berlin—neugerriemschneider—was extremely productive in this way.

Hans Ulrich Obrist —— **And what about the shared studio space with Tacita and Thomas?**

Olafur Eliasson —— Yes, we all spend a lot of time in the studio—not necessarily all of it working. So in that sense there's a bit of a community. And, of course, there are all the other people working there, as well, which creates a kind of "glue" that turns the whole thing into a small community. There's also the fact that my space is located between Thomas and Tacita—and that I have a large kitchen with a coffee machine. You know how things work when you're the one with the coffee machine—it's where people tend to hang out!

Hans Ulrich Obrist —— **How is your working relationship with Thomas? Is it osmotic?**

Olafur Eliasson —— Thomas, as you can imagine, is very orga-nized and clear about where or how he draws his line. I'm actually more the type who occupies things. So I'm not sure I would describe our working relationship as osmotic. In fact, we have different working methods and, formally, he is very far away from me. The closest we ever got to a collaboration was when Thomas bought a very sophisticated paper-cutting machine, and I instantly sent one of my people off to learn how

to use it so we could profit from Thomas' investment [*laughs*].

Hans Ulrich Obrist — You have a lot of people working for you. That's maybe another aspect we should talk about. When we first met, you had one assistant, but now your studio is as big as a mid-sized architecture office, with almost fifty people.

Olafur Eliasson — Well, at the moment, there are about thirty-five of us.

Hans Ulrich Obrist — Which is the size of Fumihiko Maki's office. Maki told me once, as have several other architects, that he never wanted to grow far beyond thirty or forty. If an office is too big, it doesn't always produce intelligence, but eliminates it—and creativity. On the other hand, Jacques Herzog, Zaha Hadid or Rem Koolhaas have hundreds of employees, and it still seems to work very well. So there are very different rules, very different ways of inventing an office. But in the art world, there are only a handful of artists with so many assistants: So I'm very curious how you deal with the complexity of a growing office and how you ensure that it produces intelligence and doesn't become something you have to escape.

Olafur Eliasson — A couple of years ago it really expanded and I went from fifteen people to twenty-five, thirty-five, forty-five. At some point, I even had fifty, but now we're back down to around thirty-five people. In any case, it's important to keep in mind that there's a fundamental difference between the infrastructure of an architectural office and that of my studio, where people's job descriptions vary considerably. For instance, I have two electricians, two blacksmiths,

a carpenter, a furniture builder, as well as geometricians and artists. I also have two people who are educated in stage design and theater. Then, of course, I have a group of architects, but even within that group there are large differences: some of them are from the world of graphic design, some do very sophisticated 3D-drawings, and some are more hands-on. I have an electrical engineer, and I have a light planner. Occasionally, I have one or two model makers, just as architectural offices do. Finally, the office itself is divided into rather diverse areas: I have a publication department and an archive with two or three art historians. And then there's the bookkeeper and a project manager.

But despite the number of people, it's still very clear, very hands-on, and it's also hierarchical to some extent. There's no point in suggesting that it's a kind of a community where everybody is deciding everything together. It's clearly organized around a system. This is not to say that I'm always making the decisions, because I'm not. I do make crucial decisions about what I feel is artistically important, but there are still hundreds of decisions about bookkeeping, for instance, that I'm not aware of. Sometimes it eats up my time to talk to everyone, but I don't have the feeling that it's difficult to run. And, at the end of the day, when I look back at what we've achieved, I usually feel that we've been very productive.

Hans Ulrich Obrist —— It's also a laboratory of new ideas—a place, for example, where conferences take place.

173

Olafur Eliasson — Yes, it has increasingly taken on a life of its own. Of course, it's still guided by the projects we do, and essentially it reflects its surroundings—it's not an autonomous body living encapsulated far away from its surroundings. It's part of the city in which it is; it's part of Berlin. There aren't many areas located today where experiments are actually taking place, as Molly Nesbit has pointed out. There's great potential in the fact that this laboratory has a life that's partially communicated to the outside, via the experiments that are brought out, to some extent, in the exhibitions. However, the exhibitions essentially show the nature of the experiment rather than the experiment itself. So there's something in the laboratory that's rather unique, and this is why it's almost like a body with its own life—with its own ideas and mind and production and economy. I've increasingly started doing things such as small symposia and workshops in the studio. I think the next step will be a school—an art school, if you want to call it that. It will be a school for spatial experiments in close affiliation with the studio. However, it's not about education, but about creating language to communicate. I think people are going to receive an education regardless of whether I found a school or not, but they're going to speak different languages, and what I'd like is to create a stronger affiliation to language. Then, hopefully, what one says in the language will also make sense.

Hans Ulrich Obrist — We spoke about many different types of vessels earlier today—the gallery as a vessel, neugerriemschneider as a vessel, your studio with Tacita and Thomas as a vessel. But what about the idea of the museum as a vessel? You

recently installed an incredible piece at the Lenbachhaus, which addressed light conditions within museums. Marcel Broodthaers said the museum is one reality that's surrounded by many other realities that are worth being explored. Although we've already discussed your major museum shows with ARC [Musée d'Art moderne de la Ville de Paris] and the Tate, we haven't talked about your recent explorations of museums' more structural aspects. In Munich, it's an almost invisible intervention, at least at first glance. It really has more to do with ...

Olafur Eliasson — Temporality.

Hans Ulrich Obrist — Temporality! Maybe we could talk about Munich first, and then about museums in general.

Olafur Eliasson — Yes, in the space at the Lenbachhaus in Munich there's normally daylight coming through the ceiling. We closed it off, and then I put in a light system that can be adjusted to emit different qualities of white light. It's playing with the fact that there's a Kandinsky show with some of the paintings that Kandinsky produced on a journey from St. Petersburg to Tunis, if I'm not mistaken; I think he went via Stockholm, Germany, Italy, Sicily, and then on to Tunis. So we tried to record the light from the places where he executed the paintings, and then we took that and put it in the gallery where the paintings are hanging. It's not necessarily about the right way to illuminate the paintings—it's about the fact that white light is also constructed and not, as we might think, to be taken for granted. It's about the fact that our relationship to light is a cultural and geographical matter

and not a natural one. So in this sense, the intervention in the museum is also about showing that art is not necessarily always or only on the wall, but also placed within an institutional frame that offers conditions for the experience of looking at the paintings.

As Daniel Birnbaum has remarked, we've come to an end with the biennales—with the mega-shows like the *documenta*. The format has collapsed. There isn't enough content being produced out of these, and we're all so saturated in the formal set-up of these places that we don't read the content anymore. We go through them in a very unproductive manner and are now in a situation where we need to find new ways of doing things. And it's not necessarily the form, but rather the nature of our relationship to the form of the show that's not working. A museum is perfectly capable of reinventing itself without changing its architecture—which brings us back to what I said about what constitutes the generation I'm part of. It's not the form or the walls, but the ways we share an interest in re-inventing reality. This is what the museum in Munich has adapted to.

Hans Ulrich Obrist —— **The Lenbachhaus?**

Olafur Eliasson —— Yes, the Lenbachhaus has adapted to this, embarking on a path that questions whether it's possible to challenge this very dominant modern idea of the truth—whether it's possible to challenge authorship and authenticity, and to do it in the context of modern masterpieces by Kandinsky, which I think

is very daring considering the conservative nature of most museums today.

Hans Ulrich Obrist —— This leads us back to the question of the light we see in museums. It's closely related to the white cube. It's really by convention that, at a certain moment, the decision was made that the color white should be used. In the panel discussion, you said it could easily have been a different color—yellow, for example. It's the same thing with our interview today—we could just as easily have done the interview in German or French. It's just that the decision was made at a certain moment to proceed in English. White is the color of museums, and obviously the whole history of modern architecture is related to this color. Let's talk about museums and color.

Olafur Eliasson —— White, of course, is not just a color, but a concept—a matter of upbringing and culture. There's the idea, for instance, that white has a disinfecting effect on the body. The idea of early modern architects was to suddenly purify space by rationalizing the color away, turning white into this unbelievably dominant idea of liberation. And somehow we now take it for granted that this is the natural environment for viewing art. This is not all about changing our desire or changing the color white, but rather realizing that things are often more culturally constructed than we think.

Hans Ulrich Obrist —— My last question, Olafur, is one I've asked you many times before: what is your favorite unrealized project?

Olafur Eliasson —— I would like to build a museum—to re-evaluate the nature of a museum and build it from

scratch, not renovate an old one. It should be both an art school and a museum, and in between the two there should perhaps be a little hotel—a place where people come and spend time.

Hans Ulrich Obrist —— **A relay?**

Olafur Eliasson —— Yes, and maybe the rooms themselves will be the artworks. Maybe the way people end up spending time in the hotel rooms will be what the students do and the museum shows. Maybe the life in this building is what, from a museological point of view, will be the performative element. And the building itself is just the form—it's a content machine.

Hans Ulrich Obrist —— **Ah, yes—another vessel! This is our vessel interview, and that should be part of the title.**

Olafur Eliasson —— A vessel interview—it's its own vehicle.

Hans Ulrich Obrist —— **Thank you so much.**

Illustrations

The works reproduced are the result of an ongoing collaboration between Olafur Eliasson and the Icelandic artist and architect Einar Thorsteinn that started in 1996. A cabinet of their geometrical studies, the Model room contains dozens of intricately constructed models of various sizes; as the studies at Studio Olafur Eliasson develop, new models are added to the collection. Interconnected shelving units present the research into spatial structures.

Olafur Eliasson

Olafur Eliasson, born in Copenhagen in 1967 and of Icelandic extraction, studied at the Royal Danish Academy of Fine Arts. In 1995 he established Studio Olafur Eliasson in Berlin, a laboratory for spatial and temporal research. Eliasson represented Denmark at the 50th Venice Biennale in 2003 and later that year installed *The weather project* in the Turbine Hall of Tate Modern, London. Recent exhibition venues include Hara Museum of Contemporary Art, Tokyo, Museum Boijmans van Beuningen, Rotterdam, and Kunstmuseum Wolfsburg. In September 2007, a large survey exhibition of Eliasson's work opened at San Francisco Museum of Modern Art, which will travel to The Museum of Modern Art in New York and P.S.1 Contemporary Art Center.

Hans Ulrich Obrist

Born in Zurich in 1968. Since 2006 he has served as Co-director of Exhibitions and Programs and Director of International Projects at the Serpentine Gallery in London, where he currently lives and works. From 1991 to the present, he has curated 150 exhibitions in various fields of contemporary art. In addition to these projects, he is the editor of a series of artist books published by Verlag der Buchhandlung Walther König, Köln.

Thanks to
(in alphabetical order)

Herbert Abrell
Ari Alexander
Klaus Biesenbach
Daniel Birnbaum
Stefano Boeri
Tanya Bonakdar
Francesco Bonami
Mark Booth
Laurence Bossé
Thomas Boutoux
Eun-Yong Cho
Thomas Demand
Anna Engberg-Pedersen
Elena Filipovic
Joachim Geil
Francesca von Habsburg
Jens Hoffmann
Noah Horowitz
Koo Jeong-A
Biljana Jokslmovic
Samuel Keller
Franz König
Walther König
Martina Kupiak
Gunnar Kvaran
M/M
Karen Marta
Akiko Miyake
Isabela Mora

Nobuo Nakamura
Tim Neuger
Suzanne Pagé
Beatrice Parent
Julia Peyton-Jones
Vivian Rehberg
Burkhard Riemschneider
Angeline Scherf
Joni Sighvatsson
Studio Olafur Eliasson
Sally Tallant
Einar Thorsteinn
Lorraine Two
Jonathan Wingfield